HANGJIA
DAINIXUAN

行家带你选

珠 宝

姚江波 ／ 著

中国林业出版社

图书在版编目(CIP)数据

珠宝／姚江波著．–北京：中国林业出版社，2019.1
（行家带你选）
ISBN 978-7-5038-9892-1

I.①珠…　II.①姚…　III.①宝石–鉴定　IV.① TS933

中国版本图书馆 CIP 数据核字 (2018) 第 278234 号

策划编辑　徐小英
责任编辑　徐小英　张　璠
美术编辑　赵　芳　张　璠　刘媚娜

出　　版　中国林业出版社(100009 北京西城区刘海胡同7号)
　　　　　http://lycb.forestry.gov.cn
　　　　　E-mail:forestbook@163.com　电话：(010)83143515
发　　行　中国林业出版社
设计制作　北京捷艺轩彩印制版技术有限公司
印　　刷　北京中科印刷有限公司
版　　次　2019 年 1 月第 1 版
印　　次　2019 年 1 月第 1 次
开　　本　185mm×245mm
字　　数　169 千字（插图约 370 幅）
印　　张　10
定　　价　65.00 元

孔雀石鸡心吊坠

南红凉山料算珠

海纹石单珠

925 银链莫莫红珊瑚葫芦吊坠

◎ 前 言

 珠宝是人类社会发展的必然产物，包含天然宝玉石、有机宝石，同时包含金银等镶嵌制品，概念十分宽泛。珠宝的产地因种类非常多而遍及世界各地。一种珠宝常常是由于地质等原因，在某一地区储藏量比较大，如高品质的翡翠基本产于缅甸；珊瑚虽然在世界上有很多产地，但以中国台湾地区的数量最多，储量最为丰富；琥珀虽然世界上几十个国家都产，如俄罗斯、乌克兰、法国、德国、英国、罗马尼亚、意大利、波兰等国都有见，但以波罗的海沿岸国家为主，特别是俄罗斯的产量可以占到世界总产量的90%以上。但也有的国家和地区盛产多种宝石，如斯里兰卡就有"宝石之国"之称，盛产红宝石、蓝宝石、石榴石、海蓝宝石、碧玺、托帕石、锆石、尖晶石等，挖一个坑里面非宝石类的石头很少见。由此可见，斯里兰卡宝石之丰富。但像斯里兰卡这样盛产宝石的国度并不是很多，大多数国家多是盛产某种或者某几种宝石，如青金石优质料盛产于阿富汗，祖母绿盛产于哥伦比亚等。

 中国也是珠宝大国，如钻石、红宝石、蓝宝石、祖母绿、黄龙玉、托帕石、绿松石、水晶、橄榄石、和田玉、南红玛瑙、战国红玛瑙、琥珀、珍珠、珊瑚等都有产。我国在新石器时代就已经开始使用珠宝了。如新石器时代由于人们运输能力有限，贝壳取自遥远的大海，所以显得十分贵重，于是人们就用贝蚌等穿系成手串等用于佩戴，炫耀其身份和地位。古代珠宝不断的发展，商周以降，直至明清，铜、金、银、骨、陶等材质不断涌现，产生了众多质地的珠宝。特别是当代，珠宝的种类如雨后春笋般地发展，如钻石、红宝石、蓝宝石、海蓝宝石、海纹石、水晶、尖晶石、金红石、钇铝榴石、珊瑚、琥珀、蜜蜡、绿松石、和田玉等，犹如灿烂星河，群星璀璨。有相当多的古代珠宝没有大规模地流行，或者流行时间比较短，只是在历史上"昙花一现"，之后很快就消失了；但有些珠宝，如金银镶嵌、和田玉、翡翠、琥珀、蜜蜡、珊瑚等，几乎穿越了整个中国古代历史的全过程，成为帝王将相和老百姓主要使用的珠宝。因此，中国古代珠宝的数量非常多。

 中国古代珠宝虽然离我们远去，但人们对它的记忆是深刻的，这一点反映在当代的收藏市场上。在收藏市场上，历代珠宝受到了人们的热捧，各种古珠宝在市场上都有交易。由于当代现代化的开采设备将过去无法开采的地方的珠宝都开采了出来，当代珠宝在数量和质量上基本都达到了历史之最。所以从

客观上看，收藏到各种珠宝的可能性比较大。但也正是因为珠宝品类繁多，收藏者不可能都一一了解，所以就给作伪留下了空间。加之珠宝多数以克拉计重，体积比较小，造型简单，所以作伪成本较低，于是各种各样伪的珠宝出现了，成为市场上的鸡肋，高仿品与低仿品同在，鱼龙混杂，真伪难辨，中国古代珠宝的鉴定成为一大难题。

　　本书从文物鉴定的角度出发，力求将错综复杂的问题简单化，以种类、质地、色彩、光泽、密度、硬度、切工、造型、厚薄、风格、打磨、工艺等鉴定要素为切入点，具体而细微地指导收藏爱好者由一枚珠宝的细部去鉴别珠宝之真假、评估古珠宝之价值，力求做到使藏友读后由外行变成内行，真正领悟收藏，从收藏中受益。以上是本书所要坚持的，但一种信念再强烈，也不免会有缺陷，不妥之处，希望大家给予无私的批评和帮助。

<div align="right">姚江波</div>

<div align="right">2018 年 12 月</div>

绿松石管·新石器时代

◎ 目 录

粉晶手串

青金石珠

水晶球

岫玉璧·民国

莫莫红珊瑚元宝

925 银莫莫红珊瑚加色雕花耳钉

马达加斯加白玛瑙筒珠

第一章　质地鉴定

第一节　概　述

一、概　念

珠宝的概念比较宽

和田白玉福瓜

泛，包含天然宝石、天然玉

石、天然有机宝石等，也有人认为还应

包括金银等镶嵌制品。古代有金银珠宝之说，当代珠宝的概念进一

步扩大。随着当代科学技术的发展，使得人造宝石如雨后春笋般地

出现，如红宝石、蓝宝石、水晶、尖晶石、金红石、钇铝榴石、珊瑚、

绿松石等都是常见的人造宝石。在功能上，这些人造宝石主要是应

用于工业领域，如人造钇铝榴石是激光工业中常见材料；人造水晶

不仅仅是在灯饰行业中有用，而且是控制和稳定无线电频率、声呐

发射元件等方面较为理想的材料。但不可否认，有很多被用来制作

珠宝的伪器，这是不应提倡的。

清代三色翡翠玉镯

天河石碗（三维复原色彩图）

蜜蜡串珠

红珊瑚阿卡枝

作为珠宝来讲，还是以天然的为最好。天然珠宝形成时间很长，因此很多天然珠宝实际上具有不可再生性。根据"物以稀为贵"的商品属性，这样才具有贵重性以及保值、升值的功能。

目前关于珠宝广义和狭义的概念有很多，本书认为，根据以上珠宝的特点，不妨将天然的宝玉石，包括有机宝石以及金银与珠宝的镶嵌品等定性为狭义珠宝概念；而将包含人造宝石的珠宝定性为广义珠宝概念。由此可见，无论是狭义还是广义的珠宝概念，实际上所囊括的内容都十分宽泛，鉴定时应注意分辨。

石英岩玉吊坠

清代翡翠翠花

孔雀石手串

粉晶手串

天河石单珠

二、天然宝石

天然宝石在珠宝当中占有重要的地位，种类繁多。常见的主要有钻石、红宝石、蓝宝石、猫眼、碧玺、尖晶石、锆石、托帕石、橄榄石、石榴石、天河石、透辉石、顽火辉石、普通辉石、变石、变石猫眼、祖母绿、海蓝宝石、锂辉石、红柱石、空晶石、矽线石、蓝晶石、鱼眼石、方柱石、柱晶石、黝帘石、天蓝石、符山石、硼铝镁石、塔菲石、蓝锥矿、重晶石、芙蓉石、发晶、紫晶、长石、月光石、透视石、蓝柱石、磷铝钠石、赛黄晶、硅铍石、日光石、拉长石、坦桑石、绿帘石、堇青石、榍石、磷灰石、辉石、天青石、方解石、冰洲石、斧石、锡石、磷铝锂石、镁铝榴石、水晶、黄晶、烟晶、红水晶等。

这些宝石有些是我们所熟悉的，如钻石、红宝石、蓝宝石、猫眼、碧玺、托帕石、橄榄石、海蓝宝石、祖母绿等；有些是我们所不熟悉的，如磷铝锂石、锂辉石、矽线石等。

当然，随着天然宝石热潮的到来，这些宝石会越来越多地被我们所熟悉。如果从材质来看，一些宝石仅仅就是矿物，如钻石的矿物名称是金刚石；猫眼、变石、变石猫眼都是金绿宝石；碧玺是电气石；托帕石是黄玉；黄晶、烟晶、绿水晶、芙蓉石、发晶、紫晶等各种水晶都是石英；日光石是奥长石等。

橄榄石摆件　　　　　　　　　　红绿宝石银吊坠　　　　　　　　　　黄晶摆件

芙蓉石摆件

橄榄石摆件

紫晶摆件

　　可见，这些宝石都是自然界的矿物晶体。不过，一旦这些矿物晶体成了珠宝，那么它的价值就会根据硬度、稀少程度等被分出三六九等。如钻石、红宝石、蓝宝石等就是比较高档的珠宝品类；而像橄榄石等就是中低档的宝石。从价格上看可以说是有天壤之别。

　　从大小上看，宝石的体积特别大的不多，多数是以克拉来计算。我们知道，5 克拉才是 1 克，可见宝石在体积上通常不大。但是偶然也有大的，这时该宝石的价值就会"青云直上九重天"。另外，宝石的珍稀程度还受到色彩、净度、透明度等诸多方面的影响。若在这些方面都达到了极品，那么这件宝石才可以算得上是稀世珍宝。

红水晶摆件

青金石摆件

三、天然玉石

天然玉石是珠宝重要的组成部分。常见的天然玉石品种主要有翡翠、和田玉、欧泊、白欧泊、黑欧泊、寿山石、田黄、青田石、水镁石、苏纪石、异极矿、云母、白云母、锂云母、火欧泊、玉髓、玛瑙、蓝玉髓、绿玉髓（澳玉）、木变石、虎睛石、鹰眼石、石英岩、水钙铝榴石、滑石、硅硼钙石、羟硅硼钙石、方钠石、赤铁矿、天然玻璃、黑耀岩、玻璃陨石、鸡血石、针钠钙石、绿泥石、蛇纹石、岫玉、独山玉、查罗石、钠长石玉、黄龙玉、东陵石、蔷薇辉石、阳起石、绿松石、青金石、孔雀石、硅孔雀石、葡萄石、大理石、汉白玉、白云石、蓝田玉、菱锌矿、菱锰矿、萤石等。

可见，天然玉石的种类十分丰富。当然，本书中天然玉石的标准显然属于广义玉石的范畴。汉代许慎《说文解字》称玉为"石之美有五德"，所谓五德即指玉的五个特征，凡具温润、坚硬、细腻、绚丽、透明的美石，都被认为是玉，而不仅仅是软玉和硬玉的概念。

黄翡鱼

和田玉青海料琉璃狮子拼合印章

黄龙玉桶珠

因此，珠宝中天然玉石的概念更加宽泛，几乎囊括了所有美丽的石头。从珍稀程度上看，天然玉石的评价标准是多方面的，如硬度，几乎所有的天然玉石必须要达到一定的硬度，像和田玉和翡翠等的硬度都特别大。但是只有硬度还不行，细腻程度也必须要达到，还有净度也要达到，以及还要受到色彩、透明度等多方面的影响。只有在这些方面都达到了最高的水平，才算是比较好的质地。

但这种质地还是要受到稀少程度的影响，如果产量非常多，那么即使再好的天然玉石在价值上也不会很高，因为它不具备"物以稀为贵"的基本价值原则。鉴定时应注意分辨。

东陵石镯（三维复原色彩图）

青金石镯子（三维复原色彩图）

南红凉山料算珠

红玛瑙摆件

南红凉山料手链

红玛瑙摆件

莫莫红珊瑚珠横截面

四、天然有机宝石

　　天然有机宝石也是珠宝的重要组成部分，而且特别受到人们的喜爱。常见的天然有机宝石主要有珍珠、珊瑚、蜜蜡、琥珀（血珀、金珀、绿珀、蓝珀、虫珀、植物珀）、煤精、象牙、玳瑁、砗磲、硅化木等。可见，有机宝石品种不及宝石和玉石多。

　　从数量上看，天然有机宝石在数量上也是比较稀少的。如珍珠可以分为天然珍珠和养殖珍珠。天然珍珠又可以分为海水珍珠和淡水珍珠，数量特别的少，非常珍稀。而养殖珍珠也分为海水养殖和淡水养殖两种，在数量上比较多，但是珍稀程度也是有限。因此对于珠宝而言，数量和珍稀程度必然是成正比的，数量少自然就珍贵；而数量多珍贵程度自然就下降了。这一点，我们在鉴定时应注意分辨。

珍珠标本

莫莫红珊瑚雕件

砗磲摆件

925 银嵌珍珠戒指

　　从本质上看，有时候对于有机宝石来讲，许多不同种类的天然有机宝石其本质是同一种物质。如蜜蜡、金珀、绿珀、蓝珀、虫珀等，其实从本质上讲都是琥珀。而在这些有机宝石之下，如蜜蜡之下，还可以衍生出不同的品类，如老蜡、浅黄蜜蜡、鸡油黄蜜蜡、橘红蜜蜡、米色蜜蜡、青色蜜蜡、褐色蜜蜡、米白色蜜蜡、白色蜜蜡、棕色蜜蜡、蛋清色蜜蜡、绿色蜜蜡、土色蜜蜡、咖啡蜜蜡、红棕蜜蜡等，光怪陆离，使人眼花缭乱。而这时，本质特征就显得比较重要，鉴定时应注意分辨。

蜜蜡如意

蜜蜡串珠

　　从价值上看，天然有机宝石在价值上各不相同。有的价值连城，有的价值平平。这主要取决于其珍稀程度、净度、色彩、透明度、密度、重量、硬度等诸多因素。只有在诸多因素都达到的情况下，天然有机宝石才会具有相当的价值。鉴定时应注意分辨。

孔雀石鸡心吊坠

五、人文历史

珠宝的品类众多，除了物理性质上的硬度、比重、折射率、透明度等方面的特征外，珍贵与否与其有无历史人文背景有着密切的关联。因为珠宝本身就是比较硬、比较漂亮的各种各样的美石，本没有价值。

珠宝的价值从本质上讲应该都是历史赋予的，或者说是历史上的人们所赋予的。这样的例子比比皆是。如翡翠，在中国古代几千年的岁月里，在新石器时代、商周、秦汉、唐宋等王朝都是普通的石头，只是到了清代，因得到乾隆皇帝的垂爱后，附庸风雅也罢，回归自然也罢，反正翡翠被当时最有权势的人推崇，至清代中期之后翡翠就迅速蹿红。在当时来讲，很多人对于翡翠是持有怀疑态度的，因为一种珠宝的兴起必定要有历史，然而翡翠在当时就没有，犹如一匹黑马，所以有些人认为它不一定能够持久。的确有这种可能性，因为当代和古代许多玉石品种很多都是这样。但是历史再一次给了翡翠机遇，在清代后期，有一位不是皇帝胜似皇帝的人物再次垂青于翡翠，这就是统治中国达到半个世纪的慈禧太后。这样，翡翠的地位更加稳固，在清代已经超过了和田玉器。而在当代，翡翠被赋予了更多的人文力量，美好者价值连城，完成了由普通石头到珠宝的蜕变。

由翡翠这一实例，我们可以体会到，人文历史对于珠宝的影响的确相当巨大。又如和田玉，在新石器时代直至明清、乃至当代都不断地被赋予人文内涵，因此在我们的思想中，和田玉是珠宝的概念根深蒂固，是每一个人孜孜以求的。

南红保山料执壶（三维复原色彩图）

清代翡翠挂件

翡翠平安扣

从国内和国外看，珠宝由于受到人文历史因素的影响，文化的不同，人们对于一些珠宝的看法也不同。如橄榄石在国外较为常见，应该算是中等宝石，特别是在欧美都非常的流行；但是在国内由于缺乏文化上的认同，其价值比在国外要低许多。如张家口的橄榄石各方面基本上都是世界上最好的矿之一，但是国内真正对于橄榄石感兴趣的人少之又少，价格也是平平，而不像欧洲等国家对于橄榄石趋之若鹜，就是这个道理。另外，和田玉也是这个道理，和田玉在国内较为流行，这是因为和田玉在中国具有几千年的历史，人们将自己的喜怒哀乐都浓缩到了和田玉之上，造型几乎涉及方方面面。特别是在商周时期，和田玉与玉礼器相连，象征等级与权力。玉礼器在整个原始社会和奴隶社会占据着统治地位，为人神交流的神物，国之重器。因而它们的做工都十分精细，造型最为精致，选料考究，纹饰精美，线条流畅，凝重严谨，从整器上看，造型隽永、雕刻凝炼，件件都堪称是国之珍宝，仅观其形就能使人感到震撼。和田玉被统治阶级利用后成为权力和地位的象征，具有较高的历史、科学、艺术价值。玉礼器不仅仅是工匠们用生命雕琢的精美绝伦的艺术品，更是集聚了相当多的历史信息，是珍贵的历史文物，具有艺术品和文物的双重功能。其实很多珠宝都具有这方面的功能，只是强弱的问题。我们在鉴定时要注意区分当代艺术品和古代艺术品。

橄榄石摆件

橄榄石执壶（三维复原色彩图）

精美绝伦的玉璧·西周晚期

　　可见，人文历史是珠宝的魂，没有灵魂的珠宝总是苍白的。如近些年来新登上国家珠宝玉石名录的黄龙玉等，虽然价格很高，由于没有太多的历史，多被人们所诟病和质疑。从艺术品欣赏的角度来看，品质优的黄龙玉的确是非常漂亮，极具欣赏性，应该具有很高的价值。但黄龙玉由于没有历史作为参考，今后保值升值的潜力究竟如何，我们只能拭目以待。

黄龙玉貔貅

石英岩玉貔貅

第二节 质地鉴定

一、硬 度

硬度是珠宝抵抗外来机械作用的能力，如雕刻、打磨等，同时也是珠宝鉴定的重要标准。民间俗话常说"石头硬到一定程度就成为宝石"，这话不无道理。世界上最贵重的石头就是钻石，而钻石也是最硬的石头，其硬度可以达到10，也就是说硬度达到10的石头就是钻石。依次向下，红宝石和蓝宝石的硬度是9，猫眼、变石、变石猫眼等的硬度可以达到8.5左右，祖母绿、海蓝宝石的硬度可以达到7.5～8，碧玺7～7.5，尖晶石可以达到7.5，低型锆石硬度可以达到6，高型锆石的硬度可以达到7.5～8，托帕石的硬度可以达到8左右，橄榄石的硬度为6.5～7，石榴石的硬度可以达到7～8，和田玉的硬度约为6～6.5，翡翠的硬度约为6.5～7，珊瑚的硬度约为3.5～4.0，琥珀的硬度为2～3，玛瑙的硬度为6.5～7等。

铂金钻戒

石榴石串珠

翡翠带绿弥勒佛

总之，不同的珠宝在硬度特征上不同，虽然民间说法越硬的石头越贵重有一些道理，但并不完全正确。如只有硬度达到10才能是宝石，这个道理对于有些珠宝不适应。如普通玛瑙的硬度可以达到6.5～7，而蜜蜡的硬度是2～3，但显然蜜蜡比普通玛瑙更具珍贵性。这一点我们在鉴定时应注意。对于珠宝鉴定通常的标准也都是参考硬度，这样量化的数据就出来了，只要我们测定硬度就可以进行鉴定了。但硬度显然不是辨别珠宝的唯一标准，它只是一个参考。

蜜蜡摆件

黄龙玉戒面

二、比 重

比重是鉴定珠宝的硬性标准，是辨别真伪的重要依据。对于每一种珠宝而言，比重都是一个固定的数值。而对于被鉴定的珠宝而言，比重也会有一个固定数值。二者一对比，自然洞穿真伪。通常情况下，不同的珠宝比重不同，如钻石的比重为3.52，红宝石和蓝宝石的比重为3.99，托帕石的比重为3.53～3.55，碧玺的比重为3.01～3.10，青金石的比重为2.7，琥珀的比重为1.1～1.16，翡翠的比重为3.25～3.43，和田玉的比重为2.91～3.11，玛瑙的比重为2.41～2.78，蜜蜡的比重为1.1～1.16，珊瑚的比重为1.37～2.69，水晶的比重为2.21～2.65等。总之，由比重可以看到珠宝内部的结构致密程度，如细腻与否等。密度的本质是珠宝单位体积的重量，是珠宝内部成分和结构的外化反应。内部结构越是细密，密度越大。珠宝在致密程度上比较好的，当我们用手抚摸标本之时，感觉会比较重，这主要得益于其内部良好的组织结构。另外，密度大者敲击声音清脆，反之沉闷。我们应根据这些特征来对珠宝进行综合性的判断。

莫莫红珊瑚珠横截面标本

翡翠冰种带绿花瓶吊坠

和田玉青海料黄口料山子摆件

紫晶摆件

三、折射率

折射率，是光通过空气的传播速度和光在珠宝中的传播速度之比。对于被鉴定的某件珠宝制品来讲，折射率是个固定数值，这对于鉴定是否为珠宝具有重要意义。我们来看一些珠宝的折射率，碧玺约为 3.06，琥珀折射率约为 1.53～1.543，翡翠的折射率为 1.66，通常和田玉的折射率为 1.61～1.62，玛瑙的折射率为 1.52～1.54，碳酸钙型宝石折射率为 1.486～1.66，多为 1.65，角质珊瑚的折射率一般为 1.56，蜜蜡折射率为 1.53～1.543，水晶折射率为 1.544～1.553。我们在鉴定时应测定被鉴定珠宝的折射率进行对比，真伪自然可辨。但对于古代珠宝来讲，由于包浆比较重，或者受沁比较严重，有时候不能达到 100% 的准确，还需要结合其他珠宝的鉴定方法进行鉴定。这一点我们在鉴定时应注意分辨。

黑曜石镯（三维复原色彩图）

翡翠戒指

和田玉青海料白玉观音吊坠

孔雀石珠

和田青玉手串

翡翠珠子

四、脆　性

　　脆性，顾名思义就是受到外界撞击作用时的反应。珠宝的脆性比较大，这是因为其硬度很高。一般情况下，硬度达到六七以上的珠宝，脆性就非常大了，如红宝石、蓝宝石、猫眼、变石、变石猫眼、祖母绿、海蓝宝石、碧玺、芙蓉石、发晶、紫晶、长石、月光石、玉髓、玛瑙、黄龙玉等。所以，对于珠宝而言，保护尤为重要，如果摔到地上必然会粉碎。鉴定时我们应注意到这种硬度与脆性之间的关系。

五、绺　裂

珠宝有绺裂的情况常见。绺裂形成的原因是多种多样的，绺裂存在的形式也有多种多样。绺裂在原石之上常见，在切割好之后的宝石上一般很少见，但也会有少量绺裂。绺裂，显然对宝石价值会有重要影响，因此，我们在鉴定时要特别注意观察有无绺裂的存在，即使有一点也不行。因为无论是原石还是已经做好的珠宝，如果处理不好，都会有开裂的风险，鉴定时应注意分辨。

银嵌红绿宝石吊坠

优化绿松石隔片

六、光　泽

珠宝光泽，就是光线在物体表面反射光的能力。各种珠宝在光泽上分外妖娆，对于宝石而言基本上都属于非金属光泽的范畴。但在非金属光泽内又可分为玻璃光泽、丝绢光泽、珍珠光泽、蜡状光泽、油脂光泽和金刚光泽。从金刚光泽上看，珠宝中金刚光泽的很明显就是钻石，通体闪烁着非金属的金刚光泽，熠熠生辉，分外美丽；另外，锡石也是金刚光泽。从玻璃光泽上看，红宝石、蓝宝石、碧玺、托帕石、祖母绿、海蓝宝石、橄榄石、芙蓉石、发晶、紫晶、石榴石等都是玻璃光泽，鲜亮、柔美，在光照下通体闪烁着非金属玻璃光泽。从蜡状光泽上看，珠宝中蜡状光泽质地也很常见，如绿松石、黄龙玉、岫玉等，如蜡一样细腻柔和，具有质感。从丝绢光泽上看，

和田玉青海料黄口料山子摆件

犹如丝绢般的光泽，熠熠生辉，多见于有猫眼效应的珠宝之上，较典型的如虎睛石等，光泽淡雅，润泽，不刺眼。从珍珠光泽上看，像珍珠一样的光泽，柔和、滋润，通体闪烁着非金属的淡雅光泽；另外，鱼眼石、砗磲等均是珍珠光泽。从油脂光泽上看，犹如油脂一样稚嫩的光泽在珠宝上常见，如著名的和田白玉、青玉、糖玉、青白玉、黄玉、碧玉、墨玉、琥珀、蜜蜡等都是油脂光泽，非常柔和，多数通体闪烁着非金属的淡雅光泽。金刚光泽的宝石在种类上最少见，玻璃光泽和油脂光泽数量最多，鉴定时我们应注意体会。

红绿宝石碗（三维复原色彩图）

青金石摆件

虎睛石碟（三维复原色彩图）

战国红摆件

七、透明度

　　透明度，是珠宝透过可见光的程度。珠宝在透光上的特征非常复杂，主要可以分为通透、半透、微透、不透四个层次。如无色的水晶就是通透，像玻璃一样从里面看到外面；而翡翠的豆地多数为半透明；和田玉多数为微透明；不透的情况也有很多，如翡翠的干白地等就是不透明。但珠宝在透明度上的表现往往很复杂，因为在一件器物上有可能就存在着从透明到微透明的情况，如从一些蜜蜡就表现得很明显，一部分是透明的，而另一部分又是不透明的，一

和田玉白玉佛吊坠

翡翠冰种带绿花瓶吊坠

黄龙玉随形摆件

整个小挂件演示了从透明到不透明的珠宝透明度特征。另外，还有就是同一类器物，如翡翠在透明度上从玻璃地完全透明，到豆青半透，直至干白地完全不透，表现出了在透明度特征上的多样性。由此可见，珠宝在透明度上可谓是复杂至极。但透明度也是判断珠宝价值的重要标准，最典型的还是看翡翠。翡翠鉴定要看水头，其实水头指的就是透明度。水头好的翡翠可以增加颜色饱满度，整个色彩充满在翡翠之内，生机盎然，鲜活，反之则显死板，没有生气。当然，透明度的高低与珠宝的厚薄也有关系，因此，我们在鉴定时应注意到厚度与透明度在这一点上的交集。另外，珠宝的透明度标准因珠宝的不同而相异。如翡翠显然是透明度越高越好，如水地子，像清水一样的出山泉水，川流不息，但本色不变，透明度很高；但对于黄龙玉而言，只能是微透，如果过于透明，说明内部结构不好，玉化程度不高，有类似石英的成分。所以，透明度的好与坏并非是判断珠宝珍贵与否的唯一标准，而只是一个参考，而且还必须以不同的珠宝为标准。我们在鉴定时也应引起充分注意。

紫晶执壶（三维复原色彩图）

八、吸附性

　　吸附效应的鉴定原理是利用自然界宝石类的物理现象，对于电器石类特别有效。如柜台内的碧玺效果特别明显，当然水晶、黄晶、烟晶、绿水晶、芙蓉石、发晶、紫晶等热电效应也都比较明显。原理是加热珠宝体后所产生的电压能够吸附灰尘，而人工合成的珠宝则不会产生这种物理现象，真伪自然洞穿。加热不用专门的设备，珠宝制品放在一般的柜台内就可以进行，当柜台内太阳光或灯光的热度达到一定程度，从而使珠宝产生电荷，就可以有效地吸附灰尘。这种实验很容易做，同时效果也都比较明显。

水晶球

九、静电性

珠宝鉴定中常见的一种鉴定方法，就是利用珠宝和绝缘材料进行摩擦产生静电效应。最为常见如蜜蜡、血珀、金珀、绿珀、蓝珀、虫珀、花珀等，如果同衣服等摩擦，短暂产生的静电电压瞬间力量，很容易就可以吸附起纸片。而塑料制品或者是仿制品显然不能够产生静电效应，这样立刻就可以洞穿真伪。这种检测的方法比较实用，可以在购买时随时使用，缺点是静电效应并不是针对所有珠宝的检测方法，而只有部分珠宝可以使用。鉴定时应注意分辨。

蜜蜡串珠

血珀串珠

琥珀随形摆件

十、气泡法

气泡法比较简单，就是通过观察珠宝中的气泡，来鉴定珠宝的真伪。如琥珀当中气泡多为圆形或接近于圆形，非常自然，而经过压制的琥珀或者是蜜蜡，气泡多是沿着一个方向被拉长，被压成了扁形，这样我们就可以判断其真伪。而有的珠宝则是其中没有气泡，如翡翠当中就没有气泡，如果看到有气泡的情况则必然为伪器，多是用玻璃等做成的，或者是充填的胶中有气泡。因为玻璃和充填胶当中存在着大量的气泡，像这样的情况直接就可以判定为伪器。像翡翠这样体内没有气泡的珠宝还有很多，如珊瑚当中也没有气泡，所以如果发现珊瑚体内有气泡，立刻判断为伪器。这种检测可以判断出大多数的珊瑚低仿品。但气泡法也不是万能的，并不一定适应于所有的珠宝。如人造石榴石内就有气泡。所以气泡法要根据不同的珠宝来选择性地使用，鉴定时注意分辨。

仿蜜蜡手串（筒珠）

莫莫红珊瑚摆件

十一、痕迹法

　　痕迹法是珠宝鉴定当中最简单实用的一种检测方法，但具有一定的损坏性，是否使用需要读者自己判断。如钻石的硬度非常大，理论上它可以随意刻划和田玉等较硬的玉石，可以在玉石上留下痕迹，而对钻石则没有伤害；如果不能留下痕迹，那么显然仅仅从痕迹法这一点来看，钻石就有问题。而像和田玉之类硬度的玉石又可以同样用痕迹法检测硬度低的珠宝，如琥珀、蜜蜡、珊瑚等，可以留下痕迹，而自己不受损伤。其规律性特征就是硬度大的可以检测硬度小的，而硬度小的不能检测硬度大的。鉴定时注意分辨。

红玛瑙、和田玉白玉福瓜吊坠

十二、声 音

声音是检测珠宝很重要的方法。珠宝的密度越大，理论上越致密，而越是细腻、致密的珠宝之间，相互轻微碰撞所发出的声音必然是悦耳动听的声音，反之则是沉闷短促的。如翡翠 A 货之间轻微相互碰撞敲击，发出的声音清脆悦耳；而 B 货或者是 C 货之间相互敲击发出的声音则是沉闷和短促的。同样道理，很多材质的珠宝都是这样，我们在检测时应注意体会。

十三、断 口

断口是在应力的作用下产生的破裂面，形状各异，但大致可以分为齿牙状、起伏不平状、蚌贝状、参差状、平坦状。如珊瑚的断口为平坦状，翡翠为粒状断口，水晶是贝壳状断口，和田玉的断口是平坦状的，珍珠为参差状等。由此可见，不同珠宝的断口各不相同。断口也是决定珠宝价值的重要依据，如水晶。如果是贝壳状的断口是比较好的，如果是齿牙状或起伏不平状的断口，就意味着水晶体内部可能会有重大缺陷，如果用来做雕件，受力后很容易就碎掉了。总之，这需要我们在鉴定时多体会。

海纹石单珠

青金石隔片

十四、刀剐法

刀剐法是对一些硬度比较低的有机宝石的鉴定方法。这是一种有损的检测方法，如琥珀、蜜蜡这一类，用刀可以剐下来一些粉末；但是如果是塑料制品制作的，那么显然剐下来的是一卷一卷的，以此来洞穿真伪。但是这种检测方法局限性也比较大，所针对的珠宝类别过于单一，鉴定时应注意分辨。

仿蜜蜡手串（圆珠）

琥珀随形摆件

珊瑚碗（三维复原色彩图）

阿卡珊瑚碗（三维复原色彩图）

十五、产　地

产地特征对于鉴定特别重要。因为一种珠宝常常是由于地质等原因，在某一地区储藏量比较大。如高品质的翡翠只有缅甸有，其他国家和地区很少；珊瑚产于温暖的海洋之中，基本上在赤道和近赤道的海域都会有珊瑚产生，如印度洋、太平洋、大西洋等的赤道附近浅海区有见，而不能在北冰洋等地区出现。中国、日本、阿尔及利亚、突尼斯、摩洛哥、意大利等都有较好的珊瑚产出。而琥珀虽然世界上很多地方都有产，但产量最大的主要还是国外，以波罗的海沿岸国家为主，如俄罗斯、乌克兰、法国、德国、英国、罗马尼亚、意大利、波兰等国都有见，特别是俄罗斯的产量最大。另外，美洲、中东、亚洲等地也都是琥珀出产地。美洲的多米尼加最为著名，

琥珀随形摆件

其他的如墨西哥、智利、阿根廷、哥伦比亚、厄瓜多尔、危地马拉、巴西等国都产琥珀。还有新西兰也是重要产地。亚洲的缅甸也是重要产区。而水晶的产地很多，从世界上来看，中国、印度、危地马拉、马达加斯加、土耳其、意大利、美国、法国等都产水晶。以上是以珠宝追踪产地，这种方法比较系统和深入，但是很单一，下面我们来看一下主要国家和地区所产宝石的情况。斯里兰卡有"宝石之国"之称，如红宝石、蓝宝石、石榴石、海蓝宝石、碧玺、托帕石、锆石、尖晶石等都产，而且数量比较大。很多人风趣地说斯里兰卡到处是石头，随便一挖就可

红水晶摆件

以挖出不同的宝石，由此可见，斯里兰卡宝石之丰富。当然除了斯里兰卡外，缅甸也是一个不折不扣的珠宝王国。在缅甸，不仅产翡翠，而且还有橄榄石、蓝宝石、猫眼、碧玺、青金石、堇青石、黄龙玉等。像这样的国家很多，如非洲的坦桑尼亚也是重要的宝石大国，该国出产坦桑石、红宝石、蓝宝石、碧玺、石榴石等。其实我国也是珠宝大国，如钻石、红宝石、蓝宝石、祖母绿、黄龙玉、托帕石、绿松石、水晶、橄榄石、和田玉、南红玛瑙、战国红玛瑙、琥珀、珍珠、珊瑚等。另外，我们再来看一些特别的珠宝玉石产地：如青金石世界上最重要的产地就是阿富汗，优质青金石的产量世界第一；我国宝岛台湾是世界上珊瑚产量最大的地区；哥伦比亚是祖母绿最重要的出产国等。鉴定时应注意。

天河石单珠

战国红摆件

珍珠标本

莫莫红珊瑚寿星

十六、手　感

手感，即是用手触摸珠宝的感觉，如琥珀是光滑的，轻盈的，而和田玉手感是油性的，但是也是相当重的。几乎所有的珠宝都有手感，如珊瑚的手感是润泽、细腻、光滑、温润的，但是温润光滑的程度会随着品级的降低而下降。一般情况下是活珊瑚最好，而死珊瑚往往有涩感。因而手感作为一种鉴定方法它并不是唯心的，也是一种科学的鉴定方法，而且是最高境界的鉴定方法之一。收藏者在练习这种鉴定方法时需要具备一定的先决条件，就是所触及的珊瑚必须是真品，而不是伪器，如果是伪器则刚好适得其反，将伪的鉴定要点铭记心中，为以后的鉴定失误埋下了伏笔。

孔雀石鸡心吊坠

十七、净　度

净度，就是指珠宝的纯净程度，也就是杂质的情况。自然之物杂质显然是不可避免的，没有杂质的珠宝理论上是不存在的，只是杂质在轻微程度上有区别。视觉观察不到的即是纯净；如果能够观察到，但非常稀少，杂质非常小的，这样的情况我们称之为轻微杂质；杂质很明显，而且分布很广的情况是严重杂质。

净度其实是一个既简单又复杂的概念，如翡翠，净度高的如玻璃种、冰种、水种等都可以；而如青花种、豆青种等杂质其实很普遍，几乎无法通过切割来避免。而净度又是决定翡翠优劣的标准之一，通常同种的翡翠在匀净程度上越好，价值越高，

黑曜石貔貅

青金石串珠

孔雀石碗（三维复原色彩图）

翡翠冰种四季豆吊坠

砗磲手串

反之则价值越低（不同色、不同种的翡翠之间没有可比性）。对于珊瑚而言也是这样，净度越高价值越高，反之则会朝着相反的方向发展。

总之，净度概念贯穿于所有珠宝之中，几乎每一种珠宝都有其对于净度的要求，鉴定时我们应注意分辨。

翡翠冰种带绿花瓶吊坠

红绿宝石银吊坠

十八、珠宝辐射

珠宝是美丽的，但它具有其自然属性的一面，这一点是本书需要提醒读者，与读者共勉的。一般来讲，天然的珠宝辐射危害性不大，因为这些珠宝的原石宝石都是与地球岩石一起共生，其放射性早已衰变，不具危害性，较麻烦的就是人工辐射的情况。一般情况下，人工辐射后一段时间珠宝才能上市销售，所以危害性基本不存在。但是这是正规厂家的做法，一些小厂根本不讲究这些，所以在购买珠宝时一定要选择正规的生产企业，再者多选择天然的。因为目前市场上也还有不和谐的音符。

朱砂手链

南红凉山料摆件

众所周知，锆石分为高型和低型。低型锆石辐射较为严重，可以穿透人体，对于人体有损害。但是低型锆石市场上偶有见，可能销售它的人也不懂，这个时候我们应迅速告之，赶快避开。

宝石虽美，但有的时候越是美的东西越是冷艳的，所以我们要多研究，要取其精华，剔除糟粕，将宝石带给人们的伤害降到最低。总之，一定要到正规的商场和有信誉的知名企业购买，或者是咨询专家，这样可以将危害降到最低。

925 银嵌锆石戒指

925 银嵌锆石戒指

925 银嵌锆石戒指

翡翠带绿水滴

第三节 辨伪方法与仪器检测

珠宝的辨伪方法主要包括三种：第一种是对古代珠宝文物性质的辨伪，也就是古董珠宝的辨伪；第二种是对老料新工制品的辨识；第三种是对新材质作品的辨伪。其实，三种辨伪方法虽然在细节上不同，但就方法而论是一种，即人们用来达到珠宝辨伪目的的手段和方法的总和。因此，辨伪方法是用于指导我们的行为，以及对于古代珠宝辨伪的一系列思维和实践活动，并为此采取的各种具体方法。可见，在鉴定时我们要注意到辨伪方法在宏观和微观上的区别。另外，还要注意到对于珠宝的鉴定和辨伪，不是一种方法可以解决的，而是要多种方法并用。

虎睛石手镯（三维复原色彩图）

翡翠冰种戒面

　　在珠宝的辨伪当中，科学检测显然已经成为一种时尚。许多珠宝制品本身就带有国检证书。但是，证书并不代表一切，证书只能证明检测的成分，不能检测珠宝的使用年代，不能辨别是汉代的还是六朝的，同时也不能辨明它的优劣，当然也不能辨别人工合成的珠宝。人工合成的珠宝，就是将珠宝打成粉，之后再将其黏合压制成型。这样的珠宝欺骗性很高，因为检测结果都是珠宝的成分，也可以出具检测证书。因为有的证书只写是否为珠宝质地，并不写是否有优化处理的情况。

　　因此，仪器检测，只是我们鉴定珠宝的第一步，但显然不是全部。对于珠宝鉴定而言，需要以仪器检测为依据，综合其他鉴定要点，全方位地进行检测。

925 银链莫莫红珊瑚松鼠吊坠

第二章　时代特征

第一节　旧石器时代珠宝

　　珠宝在中国的历史源远流长，新石器时代，人们已经开始区分各种石头的好坏。我国先民对玉质的认识较早，我国最早发现的一件玉器是新石器时代晚期山西峙峪遗址出土的水晶制的小玉石刀（贾兰坡等，1984）。这是目前学界较认可的我国最早的珠宝类实物，说明我国至少在新石器时代就有了成熟的珠宝制作技术，也意味着从这第一件珠宝开始，中国古代辉煌的珠宝文化便开始了，同时珠宝的鉴定和辨伪工作也就开始了。因为珠宝辨伪是一项综合性很强的工作，不是简单的真与伪的辨识问题，必须将其纳入时代的背景之下，才能更好把握。但总的来看，珠宝的辨伪还是有一定规律可循的，在具体鉴定时一定要充分使用这些规律。

石核·旧石器时代

鸵鸟蛋化石·旧石器时代

青玉铲·新石器时代　　　　　　　　　　青玉铲·新石器时代

第二节　新石器时代珠宝

　　新石器时代珠宝主要以玉器为主。大约距今 6000 年左右，在我国就形成了玉器文明，如北方地区的红山文化和南方地区的良渚文化等，都是在这一时间段形成的古玉器文明。最终，红山文化和良渚文化共同将中国古拙玉器文明推向了巅峰，使之成为中国古代文明的象征，这就是光辉灿烂的原始社会古拙玉器文明。在这些玉器当中有软玉，但是和田玉很少。红山文化当中透闪石类的质地比较

良渚文化玉琮·当代仿古玉

红山文化玉猪龙·当代仿古玉

常见；良渚文化玉器当中也有少量的软玉制品，同时也有见玛瑙、绿松石、水晶等不同类型的珠宝。如新石器时代水晶石坠"95TZM140：3，通体光滑"（青海省文物管理处等，1998），这件水晶吊坠的功能与我们当代的水晶吊坠已无太大区别，可见在新石器时代人们就在佩戴美丽的吊坠。另外，还有见绿松石管、串饰等制品，也有见少量珊瑚等制品。由此可见，新石器时代珠宝体系的主要类别已经形成。

绿松石管·新石器时代

绿松石串珠·新石器时代

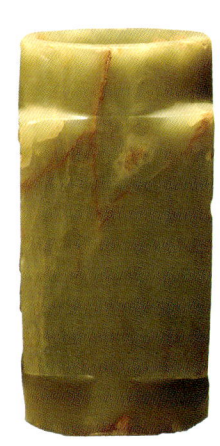

虢国和田青玉琮·西周

第三节　商周秦汉珠宝

　　商周时期中国古代珠宝延续传统继续发展，在体系上更加完备，在工艺上创新不断。从夏商之际的丹凤眼兽面纹上可以看到夏代珠宝镶嵌工艺的成熟。该类型纹饰多出现在商早期，实物资料如："铜牌饰凸面纹饰，由许多碎小的长方形绿松石片很整齐地镶嵌而成。两目写实，中心有圆眼球，两眉向内弯曲（1987年偃师二里头三区第11号墓出土，河南省文物考古研究所，1995）。该眼明显系人眼特征，相当写实。看来在兽面纹饰产生之初，人的形象也被考虑了进去。工匠们十分善于观察人的眼睛，将人的眼睛刻画得惟妙惟肖。从工艺上看，实际上商周时期在工艺上已经可以将珠宝打磨得相当

和田玉标本·西周

和田青玉管、红玛瑙组合·西周

光滑，圆度规整。商代水晶"在制玉工艺上成熟
地运用了砣机技术"（安徽省文物考古研究所等，
1999）。这种可以算是半机械化的制作方法使
得商周时期的珠宝工艺同当代已经没有太大
差别。

玉蜻蜓·西周晚期

　　"春秋战国玉器在造型上十分丰富，其
主要造型有玉龙、玉璧、玉环、玉瑗、玉琮、
玉璜、玉环、玉鸟、玉梳、玉珠、玉圭、玉佩、
玉串饰、玉带钩、项链、水晶管、玛瑙珠、绿
松石珠、扁玉管、玉鱼、玛瑙串珠、玉玦、玉觿等。
可见，春秋战国时期的玉器造型十分丰富，既有传统的造型，如玉琮、
玉璜、玉圭、玉龙、玉璧等，都是礼器时代经常出现的造型；又有

卷尾玉龙·西周

玉组佩·春秋早期

谷纹玉璧·战国

玉璧·春秋

较新的造型，如玛瑙串饰、水晶环等则在礼器时代的玉器造型中十分少见"（姚江波，2006）。由上可见，虽然这一时期珠宝的体系有所完善，但是在当时的珠宝领域中依然还是以玉器为显著特征，这一点似乎并没有得到根本性的改变。

秦汉时期，特别是汉代，在珠宝的体系上进一步完善。我们来看一则实例，"汉代琥珀饰，1件"（广西壮族自治区文物工作队，2003）。实际上这座墓葬随葬琥珀不只是这一种器物类型，如"汉代琥珀饰4件"，琥珀数量很大。由此可见，商周秦汉时期在琥珀出土数量上是一个相当大的进步。我们知道，琥珀制品国产数量很少，在汉代用琥珀进行随葬，可见人们对于珠宝当中的这一有机宝石的研究已经是十分深入和细致。另外，汉代珊瑚制品也是有见，可见汉代珠宝业发展很快，虽然从宏观上看依然还是笼罩在和田玉单品种的巨大阴影之下，但另外一些单品种的产品显然发展很快。

玉龙·春秋

谷纹玉璧·汉代

云雷纹玉·汉代

造型与纹饰完美结合的玉雕鸳鸯炉·唐代

第四节　六朝隋唐辽金珠宝

　　六朝隋唐辽金时期珠宝业继续发展，《晋书·吕纂载记》"即序胡安据盗发张骏墓，见骏貌如生，得真珠箓、琉璃榼、白玉樽、赤玉箫、紫玉笛、珊瑚鞭、马脑钟，水陆奇珍不可胜纪"，可见当时珠宝业发展之丰富，出现了珍珠、和田玉、琉璃、珊瑚、玛瑙等诸多珠宝，正如文献所记述的那样是"水陆奇珍"。六朝时期的珠宝业其实与当代已经没有太大的区别，只是当时由于技术的限制，在开采这些资源上还有问题，当时的珠宝可能比我们当代的同类珠宝还要珍贵许多。这一点我们在鉴定时应注意分辨。隋唐辽金时期基本上还是延续前代，我们来看一些实例，《旧唐书·西戎传·泥婆罗传》"其王那陵提婆，身著真珠、玻璨、车渠、珊瑚、琥珀、璎珞，耳垂金钩玉珰，佩宝装伏突，坐狮子床，其堂内散花燃香"。这则文献在描述西域一个人物的装扮，很形象地描述了当时珠宝的种类及人们佩戴它的情况，有珍珠、玻璃、砗磲、珊瑚、琥珀、金玉等，可见基本同六朝时期没有太大的不同。我们再看一件隋唐时期墓葬出土的器物，唐代"水晶珠1件"（徐州市博物馆，1997）。实际上，在唐墓当中不仅仅是出土了水晶，而是文献当中所述的珠宝都有不同数量的出土，从而佐证了文献的真实性。辽金时期基本也是这样，在珠宝上延续着传统。我们来看一则实例，《辽史·属国表》记载："回鹘献珊瑚树"，可见珊瑚在当时同我们当代一样是珍贵的珠宝，被用来作为贡品进献。

鸳鸯玉盒·唐代

青白玉扳指·清代

青白玉扳指·清代

第五节　宋元明清珠宝

　　宋元明清时期的珠宝基本延续前代，《宋史·外国传六·于阗传》载："所贡珠玉、珊瑚、翡翠、象牙、乳香、木香、琥珀、花蕊布、硇砂、龙盐、西锦、玉鞦辔马、腽肭脐、金星石、水银、安息鸡舌香，有所持无表章，每赐以晕锦旋襕衣、金带、器币，宰相则盘球云锦夹襕"。可见在这一时期，珠宝的品类基本上还是以和田玉、珊瑚、象牙、琥珀等为主。由于元代的版图十分广大，作为战胜国掠夺了许多珠宝首饰，元代人将这些珠宝派上了用场，和玉器镶嵌在一起，这样就增加了镶嵌玉品种，我们称之为珠宝镶嵌玉。实际上，在元代，这种镶嵌结合的玉器似乎更受到上层社会的青睐。因为，元代统治者来自内蒙古草原，本身没有使用玉器的传统，所以，他们更喜欢一些宝石。明清时期更是这样，各种各样的珠宝制品出现了，如戒指、项链、簪、手镯等都常见。如明代嵌水晶金簪"M3：43，长 1.2 厘米"（南京市博物馆，1999），由此可见，这件器物是金、水晶两种材料结合在一起成器。金嵌水晶簪在明代多属首饰的范畴。而首饰具有两大特点，一是它的贵重性，

玉蟾蜍·清代

红玛瑙卧狮·清代

二是它的实用性。二者结合在一起就构成了一件首饰，这类例子在明清时期很多。清代还别出心裁地将珠宝同当时的礼仪制度联系在一起。《清史稿·世宗本纪》有："冬十月庚子，再定百官帽顶，一品官珊瑚顶，二品官起花珊瑚顶，三品官蓝色明玻璃顶，四品官青金石顶，五品官水晶顶，六品官砗磲顶，七品官素金顶，八品官起花金顶，九品、未入流起花银顶"。可见，珠宝是同官员的顶珠联系在一起的，规定了什么样级别的官员佩戴什么样的珠宝顶珠。至此，珠宝自新石器时代以来的使用在清代达到了顶峰。当然，珠宝与礼制结合的还

清代翡翠挂件

白玉叶形镂空耳坠·清代

玉狮雕件·清代

不止是顶戴，如《清史稿·舆服志二·皇帝冠服条》载："惟祀天以青金石为饰，祀地珠用蜜珀，朝日用珊瑚，夕月用绿松石，杂饰惟宜"。还有《清史稿·舆服志二·皇后朝冠条附太皇太后皇太后条》有："朝服朝珠三盘，东珠一，珊瑚二，佛头、记念、背云、大小坠珠宝杂饰惟宜"等。

莫莫红珊瑚简珠

红绿宝石碟（三维复原色彩图）

第六节　民国及当代珠宝

　　民国及当代珠宝在使用上更加丰富。民国时期基本与前代相似，在这里不再进行过多的赘述。当代珠宝可谓是达到了历史全盛的阶段。各大商场内琳琅满目，各种各样的珠宝都出现了。当然，这与当代科学技术的发展，开采能力的提高有关，很多很难开采的珠宝现在都开采出来了。再者，进口能力的增强，随着国力的增加，过去很难得到的珠宝都可以通过进口来满足人民群众的需要。如蜜蜡，我国所产几乎是很少，但是当代市场上出现了大量的串珠、项链、手链、佩饰、把件、龙、貔貅、山子、平安扣、隔珠、隔片、念珠、胸针、笔舔、炉、印章、瓶、供器、狮、虎、臂搁、佛珠、水盂、吊坠、如意、桃子、弥勒等。这主要得益于当代原料的易得性，通过进口可以使大量蜜蜡原石进入中国，这使得蜜蜡在件数特征上进入到中国历史上最为繁荣的一个时期。相信在今日之盛世，在收藏之风的推动下，不仅仅是蜜蜡在数量上一定能够再上新高，而且其他的珠宝也多是与日俱增，点缀着人们美好的生活。从种类上看，我国目前市场上常见的珠宝主要有钻石、红宝石、蓝宝石、猫眼、变石、变石猫眼、祖母绿、海蓝宝石、碧玺、尖晶石、锆石、托帕石、橄榄石、石榴石、天河石、透辉石、顽火辉石、普通辉石、锂辉石、红柱石、空晶石、矽线石、蓝晶石、鱼眼石、方柱石、柱晶石、黝帘石、天蓝石、符山石、硼铝镁石、塔菲石、蓝锥矿、重晶石、芙蓉石、发晶、紫晶、长石、月光石、透视石、蓝柱石、磷铝钠石、赛黄晶、硅铍石、日光石、拉长石、坦桑石、绿帘石、堇青石、榍石、磷灰石、天青石、方解石、冰洲石、斧石、锡石、磷铝锂石、镁铝榴石、水晶、黄晶、烟晶、绿水晶等。这些宝石有的是人们所熟悉

翡翠豆种飘花葫芦

的，如钻石、红宝石、蓝宝石、翡翠、和田玉、猫眼、碧玺、托帕石、橄榄石、海蓝宝石、祖母绿等；但有些是人们所不熟悉的，如磷铝锂石、锂辉石、矽线石、欧泊、白欧泊、黑欧泊、寿山石、田黄、青田石、水镁石、苏纪石、异极矿、云母、白云母、锂云母、火欧泊、玉髓、玛瑙、黄龙玉、蓝玉髓、绿玉髓（澳玉）、木变石、虎睛石、鹰眼石、石英岩、水钙铝榴石、滑石、硅硼钙石、羟硅硼钙石、方钠石、赤铁矿、天然玻璃、黑耀岩、玻璃陨石、鸡血石、针钠钙石、绿泥石、

黑曜石貔貅

蜜蜡串珠

水晶吊坠

青金石串珠

石榴石串珠

橄榄石摆件

和田玉青海料白玉观音吊坠

925 银嵌锆石戒指

翡翠带绿水滴

紫晶摆件

莫莫红珊瑚鸡心吊坠

东陵石、蛇纹石、岫玉、独山玉、查罗石、钠长石玉、蔷薇辉石、阳起石、绿松石、青金石、孔雀石、硅孔雀石、葡萄石、大理石、汉白玉、白云石、蓝田玉、菱锌矿、菱锰矿、萤石、珍珠、珊瑚、蜜蜡、血珀、金珀、绿珀、蓝珀、虫珀、植物珀、煤精、象牙、玳瑁、砗磲、硅化木等。由此可见，这些珠宝在种类上之丰富，显然是集历史之大成，而且几乎囊括了天然宝石、天然玉石、天然有机宝石的所有品类。从流行程度上看，和田玉依然是占据着相当大的市场份额，但已经不像古代那样能够占据到绝对的统治地位。如钻石几乎是中国当代社会中新婚之人必备的首饰，这个量是相当大的，可以说在使用频率上已经超过了传统的和田玉，在世界上应该也是保

虎睛石手串

持着绝对的领先地位。只不过是在克拉大小上中国显然与发达国家销售的钻石还有些差别，克拉较小，但相信这种情况会随着人们生活水平的提高而改变。另外，南红玛瑙、琥珀、蜜蜡、碧玺、红宝石、蓝宝石、托帕石等在中国也都是相当的流行，有相当的购买群体。由此可见，中国当代珠宝经过几千年的发展终于突破了和田玉独大的局面，当代珠宝市场成为了一个多重珠宝相互竞技的舞台，相信这个舞台上的"演员"将会越来越多，美丽而又耀眼，像一颗颗流星从天空划过，带给人们的是更多的惬意。

岫玉璧·民国

925 银嵌珍珠戒指

南红凉山料算珠

水晶摆件

砗磲手串

第三章　珠宝鉴定

红绿宝石镯（三维复原色彩图）

第一节　宝　石

一、常见宝石

（1）钻石。钻石的矿物名称是金刚石，是一种纯碳组成的矿物。钻石，在色彩上有无色，也有淡黄色；通透；是世界上最硬的石头，硬度达到10，是一种天然宝石。钻石在目前市场上最为常见，如戒指、项链、耳环、吊坠、手链、手表、胸针等，均可以将钻石镶嵌在各种材料上作为装饰。还有与其他宝石搭配应用的，如蓝宝石配钻石胸针、天然欧泊石配钻石项链、坦桑石配钻石戒指、天然翡翠配钻石戒指、翡翠葫芦配钻石挂坠、18K 黄金镶嵌天然红珊瑚配钻石吊坠、白金钻戒等。

（2）红宝石。红宝石的矿物名称是刚玉，是一种天然宝石，十分名贵，是从古至今最为主流的珠宝之一。红宝石从透明到半透明的情况都有见；通体闪烁着非金属的玻璃光泽。红宝石在造型上由于过于小，以克拉计算，所以通常情况下是与其他材质镶嵌在一起共同组合成为器物。如翡翠、钻石、金银、玉器等都是镶嵌的对象，像白玉红宝生肖造型、翡翠配红宝石、钻石配红宝石戒指、铂金嵌红宝石戒指、黄金嵌红宝石戒指、白金嵌红宝石戒指、K 金镶嵌红宝石、红蓝宝石手镯等。另外，念珠、胸针、项链、吊坠、簪子等都常见。

铂金钻戒

铂金钻戒

红绿宝石银吊坠

红绿宝石银吊坠

红绿宝石执壶（三维复原色彩图）

红绿宝石银吊坠

（3）蓝宝石。蓝宝石的矿物名称也是刚玉，是一种天然宝石。它同红宝石一样也是相当名贵，在中国古代和当代都十分流行，是珠宝当中人们最为熟知的品类。它闪烁着玻璃光泽；断口有见参差状和贝壳状。常见的装饰器物主要有镶嵌祖母绿、蓝宝石挂链式怀表、蓝宝石配钻石戒指、蓝宝石配钻石项链、蓝宝石配钻石耳环、蓝宝石配钻石手镯、蓝宝石簪子、蓝宝石吊坠、蓝宝石项链、蓝宝石串珠等都有见。

（4）拉长石。拉长石是一种天然宝石。拉长石的色彩比较丰富，色彩变化阶段较长，如红、黄、蓝、绿、紫等色都有见，色彩偏色渐变者有见；透明度有一定的复杂性，半透明到透明的情况都有见；玻璃光泽，淡雅，柔和，精美绝伦，是大家都很熟悉宝石。

（5）碧玺。碧玺的矿物名称是电气石，是一种天然宝石。在色彩上粉红、红、绿、紫等各种色彩都有见，色彩特别的杂，品质不同在价格上差距很大；其透明度也是比较复杂的，但多数以透明为显著特征；光泽鲜亮，但不刺眼，玻璃光泽；贝壳状断口。鉴定时应注意分辨。

石榴石串珠 石榴石串珠 石榴石串珠

（6）祖母绿。祖母绿的矿物名称是绿柱石，是一种天然宝石。祖母绿在色彩上以红、黄、蓝、绿等色为多见，色彩较为稳定，但渐变色彩依然存在，色彩熠熠生辉；具较优的透明度；通体闪烁着非金属的玻璃光泽，精美绝伦，无与伦比，是一种大家都耳熟能详的宝石。由于十分珍贵，数量又特别少，所以又是大家孜孜以求的。

（7）石榴石。石榴石是一种天然宝石，也是我们在市场上常见到的。如手串、项链、串珠、吊坠、弥勒佛、观音、佛像、貔貅、牌子等，主要以镶嵌和串珠为主，目前市场上的价格不是很高，但也是属于一种中高档的宝石。石榴石色彩比较多，如红、黄、褐、绿等色都有见，以纯色为最好；在透明度上变化也是比较丰富，从透明到微透明的情况都有见；光泽淡雅，多数通体闪烁着非金属的玻璃光泽；断口为贝壳状。

石榴石手镯（三维复原色彩图）

（8）月光石。月光石的矿物名称是正长石，是一种天然宝石。月光石的知名度很高，是人们耳熟能详的宝石。色彩以白色、红色等为常见；透明度为半透明；非金属的玻璃光泽，给人以朦胧之感，美不胜收。

（9）变石。变石是金绿宝石的一个品种，市场上常见，是一种天然宝石，但数量不是太多。它在自然光下呈现出的是绿色，而在灯光下呈现出的则是淡淡的红色，故而得名。变石在透明度上特征鲜明，透明、半透明、不透明的情况都有见，我们在鉴定时应注意分辨。

（10）猫眼。猫眼（猫睛）也是金绿宝石的一个品种，是一种天然宝石。在色彩上，黄色、褐色、黄褐、绿色等都有见，有的时候是复色，如黄褐色等也都比较常见，在色彩上比较丰富；在透明度上比较复杂，从透明到半透明的情况都有见，明暗层次对比鲜明；通体闪烁着非金属的玻璃光泽；贝壳状断口，鉴定时应注意分辨。

石榴石串珠

芙蓉石摆件

紫晶摆件

（11）水晶。水晶的矿物名称是石英，是一种天然宝石。半透明到不透明。水晶的主要成分是二氧化硅，当二氧化硅纯度接近100%时呈现出无色透明晶体；如果里面含有其他矿物，依据矿物的不同，而呈现出不同的色彩，如紫色、黑色、粉色、黄色、茶色、绿色、棕色等。平坦状断口；多数通体闪烁着非金属的玻璃光泽。依据这些不同的色彩，人们将水晶分为不同的种类，如紫晶、烟晶、黄晶、芙蓉石、茶晶、墨晶等。当然，水晶当中有时还含有一些包裹体，如金红石、云母等，如发晶就是里面包裹有金色的针状金红石。从形状上看，水晶在形状上通常是六棱柱状，这是其本源性形状，但往往很多水晶结晶并不完整，从而造成了千姿百态的水晶，柱状、锥形、不规则状等，大小不一。天然水晶的大小，有的可把玩于手心，有的需用吊机进行起重运输，总之是差别比较大。

黄晶摆件

紫晶摆件

黄晶摆件

紫晶摆件

粉晶手串

茶晶珠

（12）托帕石。托帕石的矿物名称是黄玉，是一种天然宝石。从色彩上看，托帕石无色、黄、褐等色都有见，色彩渐变气氛较为浓郁，但色彩一旦形成就比较稳定；从光泽上看，光泽淡雅、柔和，玻璃光泽；透明度很高；非常漂亮，至真至纯，冰清玉洁。

芙蓉石摆件

（13）日光石。日光石是奥长石的一个品种，是一种天然宝石。在色彩上以黄、棕等色为常见，当然也有其他的色彩，色彩的渐变性还是比较强的，对着光可见晕彩现象，日光效应明显。它是人们非常喜欢的一种宝石，只是体积较大者较为稀少。

红水晶摆件

黄晶摆件

二、珍稀宝石

（1）空晶石。空晶石是红柱石的一个品种，是一种天然宝石，十分规整。多呈现出以粉红色等为基调的色彩，在色彩上有一定的渐变性；在透明度上特征比较复杂，不同的空晶石透明程度不同，有的透明，有的只是微透，或者是半透明，在同一件空晶石矿上透明度并不均匀；多数通体闪烁着非金属的玻璃光泽，光泽淡雅，柔和，并不刺眼。

925 银嵌人工合成锆石戒指

（2）矽线石。矽线石是一种天然宝石。从色彩上看，褐色、浅绿色、白色等都有见，可见在色彩上比较丰富，但纯正的色彩不是很多，主要是以组合色彩和渐变色为主；在光泽上，十分光亮，反射光的能力很强，同时闪烁着非金属的玻璃光泽；光透过程度不是很好，多数是微透明，似透非透的感觉。

（3）锆石。锆石的矿物名称就是锆石，是一种天然宝石。锆石可分为高型和低型两种，高型锆石结晶完整，在色彩上呈现出的多是无色、黄色、蓝色等，渐变性较强；透明度很高，几乎是通透的；在光泽上特征比较明确，从特别鲜亮的玻璃光泽至亚金刚光泽的都有；断口呈现出贝壳状。

925 银嵌人工合成锆石戒指

925 银嵌人工合成锆石戒指

　　（4）镁铝榴石。镁铝榴石是一种天然宝石。从色彩上看，镁铝榴石红褐色常见，但在色彩上渐变成分比较重，偏色的现象时有发生；从透明度上看，镁铝榴石透明度较高，通透性较好，光泽鲜亮，通体闪烁着非金属的玻璃光泽；断口特征为贝壳状，昭示着多数镁铝榴石内部结构没有缺陷。

　　（5）铁铝榴石。铁铝榴石是一种天然宝石。它在色彩上为深红等色，渐变色彩有见，渐变气氛较浓，偏色等现象常见；通体都是玻璃光泽；断口为贝壳状；在透明度上特征比较复杂，从半透明到透明的情况都有见，有的是在不同器物之上表现，有的是在同一器物之上表现出来。

　　（6）锰铝榴石。锰铝榴石是一种天然宝石，属于石榴石的一个品种，在色彩上主要以橙黄等色为主，色彩比较稳定，但渐变色彩依然有见，同时闪烁玻璃光泽，光泽鲜亮，淡雅，不刺眼；透明度比较好，一般情况下看起来是透明的；贝壳状断口，可雕性比较强，但通常情况下以串珠类为常见。

925 银嵌人工锆石戒指

（7）钙铬榴石。钙铬榴石是一种天然宝石，为石榴石的一个品种。色彩与祖母绿的色彩较为相似，但也有渐变的成分在里面，不过不是很严重而已；在透明度上也是比较复杂，从透明到半透明的情况都有见，有的是在同一件器物上表现，有的是在不同的器物上表现；玻璃光泽，光泽淡雅，柔和；其断口为贝壳状。

（8）钙铝榴石。钙铝榴石是一种天然宝石。从色彩上看，这种石榴石在色彩上比较明确，以红绿、淡绿等色为常见，但偏色现象也时有发生，自然之物，这一点很正常；在透明度上表现很好，多数通透；玻璃光泽，淡雅，柔和；贝壳状断口。

（9）翠榴石。翠榴石是一种天然宝石，翠榴石在色彩上比较独特，通常呈现出绿色等，也有渐变性。翠榴石为石榴石的一个品种，透明度比较好，通体闪烁着非金属的玻璃光泽；断口为贝壳状。

925 银嵌人工合成锆石戒指

925 银嵌人工合成锆石戒指

（10）黑榴石。黑榴石是一种天然宝石。其色彩为黑色等，有的时候看起来像墨色，总之是以黑色为基调的不同色彩，色彩较为纯正，为石榴石的一个品种。由于色彩的关系，通透性略逊，为微透明；光泽淡然，柔和，但绝不是黯淡，同时闪烁着非金属的淡雅光泽，属玻璃光泽的范畴；贝壳状断口。

（11）钙铁榴石。钙铁榴石是一种天然宝石，钙铁榴石在色彩上比较丰富，如黄色、绿色、黑色等都常见；通体闪烁着的是非金属的玻璃光泽，光泽淡雅，柔和，同时也有些许油脂光泽，鉴定时应注意分辨。

925 银嵌人工合成锆石戒指

925 银嵌人工合成锆石戒指

925 银嵌海蓝宝石戒指

　　（12）尖晶石。尖晶石是一种天然宝石。尖晶石的光泽较为显眼，为玻璃光泽，光泽较亮，但比较柔和，不刺眼；贝壳状断口；红、绿、紫等各种色彩都有见，总之在色彩上是比较丰富；从透明度上看，光通过尖晶石的效果较好，基本上以透明为主，鉴定时应注意分辨。

　　（13）方柱石。方柱石是一种天然宝石。从色彩上看，方柱石的色彩以紫色等为多见，但是色彩在浓淡程度上有变化；透明度比较好，通透；有着较强的玻璃光泽，亦真亦幻，非常漂亮。

925 银嵌海蓝宝石戒指　　　　　　　　　　　海蓝宝石碟（三维复原色彩图）

（14）普通辉石。普通辉石是一种天然宝石。这种宝石色彩比较丰富，如浅绿色、黑色等都是比较常见；只是在透明度上不太好，基本上是不透明的；通体闪烁着非金属的玻璃光泽，熠熠生辉，非常漂亮。

（15）海蓝宝石。海蓝宝石的矿物名称是绿柱石，是一种天然宝石。海蓝宝石在珍贵程度上通常不及蓝宝石，但优者同样价值很高。海蓝宝石在色彩上以淡蓝色、淡绿色、海蓝色、白色等色为多见，其他偏色和渐变的色彩也有见；这种宝石透明度很高，很多几乎就是透明的；光泽鲜亮，润泽，通体呈现出的是非金属的玻璃光泽。

925 银嵌海蓝宝石戒指

925 银嵌海蓝宝石戒指

925 银嵌海蓝宝石戒指

925 银嵌海蓝宝石戒指

（16）锂辉石。锂辉石是一种天然宝石。锂辉石多为粉红色，色彩艳丽，分外妖娆；透明度很高，几乎是通透的；玻璃光泽，给人极致美的体验，很多人都很喜欢。

（17）蓝晶石。蓝晶石也是一种天然宝石。色彩为灰蓝等色，色彩渐变性比较强，偏色和串色有时有见；整个晶体透明度比较高；通体闪烁着玻璃光泽；参差状断口，是一种非常具有发展潜力的宝石。

（18）天青石。天青石是一种天然宝石。天青石在色彩上变化比较大，从无色直至蓝、绿、橙、浅蓝等色都有见，可见色彩比较复杂，渐变色彩浓郁；特别透明；光泽鲜亮，多数通体闪烁着非金属的玻璃光泽，熠熠生辉。

925 银嵌海蓝宝石戒指

橄榄石摆件

（19）冰洲石。冰洲石的矿物名称是方解石，是无色、透明、纯净的方晶体，是一种天然宝石。从色彩上看多为白色，当然也有色彩的渐变，但并不严重；透明度比较高，以半透明为常见；玻璃光泽浓郁，非常美丽，鉴定时应注意分辨。

（20）斧石。斧石是一种天然宝石。其色彩以紫、褐等色为基调，如紫褐色就比较常见；透明度较高，多数是通透的；玻璃光泽，使得斧石熠熠生辉，精美绝伦，鉴定时应注意分辨。

（21）锡石。锡石是一种天然宝石。它是一种无色至浅黄等色的宝石；透明度很好，多数通体闪烁着鲜亮的金刚光泽；断口为贝壳状。

（22）磷铝锂石。磷铝锂石是一种天然宝石。其色彩为白色，有一定程度的渐变色彩；通常情况下为半透明；玻璃光泽，看上去略有朦胧感，是极其美丽的珠宝品种，十分受到人们的青睐，鉴定时应注意分辨。

（23）橄榄石。橄榄石是人们熟悉的一种珠宝，是一种天然宝石。多数为绿色，色彩有着深浅浓淡程度的变化，以色彩纯正为最好；透明度很高，光泽淡雅，柔和，非金属的玻璃光泽；其断口多呈现出贝壳状。目前市场上橄榄石通常都比较小，大的很少见，所以本身制作成为器物造型有限，以手链、串珠、项链、耳钉为主，多数是镶嵌。理论上，任何器物同橄榄石都可以镶嵌在一起组成新的器物造型，但是实际上我们在市场上所见到的并不多，主要是与钻石、黄金、白金等镶嵌在一起。如18K金镶钻吊坠、橄榄石戒指、纯银镶嵌橄榄石戒指等。总之，橄榄石并不属于非常高档的宝石，而是一种中高档的宝石，适合收藏的群体比较大，升值潜力也是很强，但一定要找到色彩较为纯正和比较大的橄榄石才有收藏价值。

橄榄石镯（三维复原色彩图）

橄榄石摆件

橄榄石摆件

橄榄石摆件

（24）透视石。透视石是一种天然宝石。透视石在色彩上以绿色、蓝色泛绿等为主；通体闪烁着非金属的玻璃光泽，光泽淡雅，柔和；透明度较为复杂，透光的程度从半透明到透明的情况都有见，是一种美丽的宝石。目前在市场上偶有见，还有待于继续开发。

（25）蓝柱石。蓝柱石是一种天然宝石。蓝柱石在色彩上比较复杂，从无色到白色、浅蓝、灰绿等都有见，可见渐变色彩，色彩十分丰富；贝壳状断口；在光泽上为玻璃光泽，熠熠生辉。鉴定时应注意分辨。

（26）磷铝钠石。磷铝钠石是一种天然宝石。这是一种无色的矿物，有时也呈现出黄绿色等，但色彩都比较浅；光泽鲜亮与淡雅并存，通体闪烁着非金属的玻璃光泽，柔和，润泽，分外美丽；通透性比较复杂，从透明到半透明的情况都有见。

（27）赛黄晶。赛黄晶是一种天然宝石。赛黄晶在色彩上比较丰富，从无色到浅黄、褐色等的色彩都有见，可见色彩的渐变气氛较为浓重；光泽鲜亮，玻璃光泽，熠熠生辉；透明度较高，通体透明。宝石级的赛黄晶被认为可以与钻石竞价。

（28）硅铍石。硅铍石是一种天然宝石。这种宝石色彩比较淡，有见无色的，同时也有见黄色，但多以淡黄色为主；通透性比较好，多数晶体透明度较高；玻璃光泽，较为鲜亮；贝壳状断口。鉴定时应注意分辨。

橄榄石摆件

橄榄石摆件

橄榄石摆件

（29）鱼眼石。鱼眼石是一种天然宝石。从色彩上看，多数为浅蓝色的晶体，在色彩上渐变的气氛有一些，但不是很严重；多数为透明，光泽鲜亮，通体闪烁着非金属的玻璃光泽，熠熠生辉。鉴定时应注意分辨。

天河石碗（三维复原色彩图）

（30）天蓝石。天蓝石是一种天然宝石。天蓝石在色彩上正如它的名字一样是以天蓝色为基调，衍生出深蓝、蓝绿等色，色彩变化幅度比较大；从半透明到不透明的情况都有见；光泽鲜亮与黯淡并存，属玻璃光泽类型，直至黯淡光泽的情况都有见。鉴定时应注意分辨。

（31）符山石。符山石是一种天然宝石。符山石当中黄绿、绿色等都有见，色彩串色等现象比较严重；在透明度上不是很好，通透的情况很少见，基本上是以半透明为显著特征；光泽淡雅，柔和，玻璃光泽；参差状断口。整个矿物看来有些许朦胧感，给人以无限想象的空间。

（32）硼铝镁石。硼铝镁石是一种天然宝石。硼铝镁石在色彩上以褐色为常见，有偏色现象；贝壳状断口；在透明度上比较复杂，从透明到半透明的情况都有见；光泽为玻璃光泽，从鲜亮到淡雅的情况都有见，有一定的变化，是一种非常美的宝石。

（33）塔菲石。塔菲石是一种天然宝石。从色彩上看无色、绿色等都有见，可见色彩变换幅度还是比较大的；贝壳状断口；透明度较好，多数为通透；光泽鲜亮，非常的艳，玻璃光泽，熠熠生辉。鉴定时应注意分辨。

天河石单珠

（34）柱晶石。柱晶石是一种天然宝石。在断口上为贝壳状；光泽鲜亮与淡雅并存，十分柔和，通体闪烁着非金属的玻璃光泽；在通透性上略复杂，从透明到半透明的情况都有见；从色彩上看，从无色到黄色和绿色等的情况都有见，可见是比较复杂，具有渐变的色彩。但正是这些色彩使得柱晶石的美不断积聚，成为一种名贵宝石。

（35）天河石。天河石的矿物名称是微斜长石，是一种天然宝石。在色彩上以蓝色、绿色为多见，渐变色彩浓郁；透明度有一定的复杂性，从半透明至微透明的情况都有见。其晶体颗粒比较细密，与翡翠相似，鉴定时应注意分辨。

（36）坦桑石。坦桑石的矿物名称是黝帘石，是一种天然宝石。坦桑石一般为贝壳状断口，具有较好的内部结构；在色彩上红褐色、蓝色等都有见，色彩的渐变气氛浓郁；通常情况下是通透的；光泽艳丽，分外美丽，多数通体闪烁着非金属的艳丽玻璃光泽，熠熠生辉。

（37）绿帘石。绿帘石是一种天然宝石。绿帘石以黄绿色、绿色等为基调的色彩为主，渐变的色彩不时有见；晶体透明程度比较好，多数为完全透明；加之玻璃光泽，使得绿帘石精美绝伦，是最美珠宝的一种。

（38）董青石。董青石是一种天然宝石。从色彩上看主要以蓝紫色为显著特征，色彩渐变、串色等比较常见，但是一旦形成色彩，通常情况下都比较稳定；透明度较高；常见有玻璃光泽，光亮，艳丽，非常漂亮。

天河石单珠

天河石单珠

天河石单珠

（39）榍石。榍石是一种天然宝石。榍石常见为浅黄、褐黄等，当然榍石的色彩远不止这些，其色彩渐变性实际上很强；从透明度上看，整体是透明的，光泽鲜亮，为玻璃光泽，分外妖娆。鉴定时应注意分辨。

（40）磷灰石。磷灰石是一种天然宝石。磷灰石在色彩上以蓝色、绿色、黄色等为常见；贝壳状断口；从透明度上看，透明到半透明的情况都有见；多数通体闪烁着非金属的淡雅玻璃光泽。

（41）透辉石。透辉石是一种天然宝石。透辉石主要以绿色等为常见，但色彩存在渐变倾向；透明度比较复杂，从透明到半透明的情况都有见；光泽鲜亮和淡雅也都有见，多数通体闪烁着非金属的玻璃光泽；贝壳状断口，内部结构较好。

（42）顽火辉石。顽火辉石是一种天然宝石。顽火辉石常见的色彩为黑褐色、绿色等，色彩渐变性比较强；通常情况下为半透明；光泽淡雅，通体闪烁着玻璃光泽，美不胜收。

（43）蓝锥矿。蓝锥矿是一种天然宝石。蓝锥矿为贝壳状断口；其色为蓝色，偏色的情况有见，渐变的气氛有见；在透明度上比较好，多数是通透的；通体闪烁着非金属的玻璃光泽，光泽淡雅柔和，精美绝伦。

天河石执壶（三维复原色彩图）

第二节　玉　石

（1）翡翠。翡翠的矿物主要组成是硬玉、钠铬辉石、绿辉石，是一种天然玉石。绿色为基调的各种色彩，黄色、墨色等；透明到不透明；油脂光泽；参差状断口。翡翠又称翠玉，如中国台北故宫所藏的著名的翠玉白菜。翠玉指的就是翡翠，是天然玉石的一种。由硬玉的矿物集合体组成，较小的晶体紧密结合在一起形成牢固的块状，其中有时含有少量的绿辉石、钠铬辉石、霓石、阳起石、钠长石、蓝闪石、磁铁矿等。化学成分为硅酸盐铝钠，主要是二氧化硅、氧化钠、氧化钙、氧化镁、三氧化二铁，并含有微量的氧化铬、镍等。但并不是具有这些特征的硬玉都是珠宝意义上的翡翠，硬玉岩型翡翠和绿辉石岩型翡翠中多见宝石级别的翡翠。世界上很多地方都产翡翠，但宝石级的翡翠产地基本上以缅甸为主。

翡翠手串

紫罗兰四季豆

翡翠带绿水滴

翡翠冰种戒面

翡翠盘（三维复原色彩图）

黄翡鱼

（2）白欧泊。白欧泊的矿物主要组成是蛋白石，是一种天然玉石。贝壳状断口；从色彩上看，主要是以白色基调为主的色彩，有渐变的成分；在透明程度上多为半透明；通体闪烁着非金属的玻璃光泽，淡雅与柔和相伴，是非常漂亮的一种玉石，鉴定时应注意分辨。

（3）黑欧泊。黑欧泊的矿物主要组成也是蛋白石，是一种天然玉石。贝壳状断口；黑欧泊主要是以黑色为主，色彩有不同程度的渐变，但是一旦色彩形成，通常比较稳定；多数为半透明；光泽淡雅与鲜亮并存，通体闪烁着非金属的玻璃光泽。

翡翠手串

翡翠带绿弥勒佛

翡翠弥勒佛

琉璃狮子和田玉青海料拼合印章

（4）火欧泊。火欧泊的矿物主要组成也是蛋白石，是一种天然玉石。火欧泊的色彩比较丰富，正如它的名字一样，从橙色到橙红等色彩都有见，变化很丰富；贝壳状断口；从透明度上看，透明到半透明的情况都有见；光泽淡雅，玻璃光泽，给人以朦胧的火焰感，非常奇妙，能给人们带来好心情，是一种不错的珠宝。

（5）和田玉。和田玉可以分为白玉、糖玉、青白玉、青玉、黄玉、碧玉、墨玉等。和田白玉的矿物主要组成是透闪石、阳起石，是一种天然玉石。微透明。关于玉质，也就是和田玉定义的问题，这是一个相当复杂的问题，主要有狭义和广义两种观点。

和田玉俄料碧玉镯（三维复原色彩图）

和田白玉福瓜

和田玉青海料黄口料山子摆件

　　我们先来看狭义和田玉，《史记·大宛列传》"汉使穷河源，河源出于阗，其山多玉石"。其主要产地和田、于田、皮山县一带较为著名，像和田县黑山矿点，古代的白玉河、绿玉河、乌玉河指的就是这个地方。目前产料最好的玉龙喀什河实际上就是古人所指的白玉河；而喀拉喀什河显然是古人所说的乌玉河。这两条河都是穿和田而过的。实际上"喀什"的名字也是因玉而来。"喀什"在维吾尔语中的意思就是玉石。河流之内主要出土籽料，即最为优质的原料。其次是于田县阿拉玛斯矿，有十几条矿脉，以出产白玉和青玉而著称，特别是白玉在产量上有一定的量。这是一个发现不是

和田玉青海料白玉观音

和田玉俄料碧玉秋叶

和田玉青海料青玉雕件牌

和田玉青海料白玉平安扣

很久的矿，历史上开采很少，主要以近代人开采为主。另外，皮山县喀拉喀什河上游有一些矿点。还有塔什库尔干地区，在县城东南几百公里左右有一些矿点，主要产青玉，古人基本上没有开采，主要是近几十年被开采过。玛纳斯天山北麓有一些矿点，以青、碧为主，这些矿点古人开采量比较大。总的来看，新疆和田玉矿分布还是比较广，点比较多，但由于历代开采得过于频繁，目前要想发现新的、

和田玉青海料、玛瑙组合手串

和田玉青海料紫罗兰葫芦

较大储量的玉矿非常困难。和田玉在新疆的产地实际上很多，从西到东整个昆仑山北麓，绵延一千多公里都有见，如且末、若羌等都有许多比较好的矿点，但一些矿点海拔比较高，在海拔 5000 多米的雪线上，比较难以开采。狭义和田玉概念比较具体，这也就是古人所认识到的和田玉，时代最迟从商周时期直至民国时期都是这样。

广义和田玉认为，只要是软玉就是和田玉，也就是成分主要是透闪石玉，在硬度、密度、折射率、比重等各个方面必须达到一定标准，只有达到这些物理标准才能称之为和田玉。这样实际上是将和田玉

精美绝伦的和田青玉戈·西周

和田玉俄料白玉吊坠

青玉璧·西周晚期

　　的概念广义化了，不仅仅局限于新疆和田地区出产的闪石类玉是和田玉。依据这个标准，在中国玉器市场上出现了和田玉的青海料、俄罗斯料、韩国料、加拿大料、贵州料、四川料、辽宁料、台湾料等，实际上广义和田玉的产地相当广大。

　　由此可见，如果纯粹从矿物学的角度来看，产和田玉的地区和国家很多，目前这些地区所产很多玉料都可以出和田玉检测证书。但这些和田玉在概念上是广义和田玉。我们在鉴定时应注意到广义和田玉和狭义和田玉的区别。从数量上看，广义和田玉的数量已经大于狭义和田玉。从时代上看，广义和田玉产品以当代为主；狭义和田玉以古代为主，鉴定时应注意分辨。

和田玉俄料碧玉秋叶　　　　　　　　　　和田玉青海料白玉带糖色鱼

（6）玉髓。玉髓的矿物主要组成是石英，是一种天然玉石。它的透明度跨度比较大，从透明到半透明的情况都有见；平坦状断口；在光泽上鲜亮与淡雅并存，玻璃光泽；色彩比较丰富，如淡黄色、绿等色都有见，色彩渐变气氛较为浓郁。玉髓是市场上最为常见的一种天然玉石，常见的器物主要有把件、吊坠、手镯、观音、弥勒、佛像、手链、串珠、项链、戒指、龙牌、生肖、平安扣、隔片、隔珠、狼牙、佛珠等。由此可见，玉髓的造型种类十分丰富。但是玉髓只是一种中低档的玉石，在价格上并不是很高。

（7）蓝玉髓。蓝玉髓的矿物主要组成是石英，是一种天然玉石。其基调色彩为蓝色等，有渐变的倾向；透明度跨度比较大，从透明到半透明的情况都有见；在光泽上鲜亮与淡雅并存，贝壳状断口，鉴定时应注意分辨。

（8）绿玉髓。绿玉髓（澳玉）的矿物主要组成是石英，是一种天然玉石。贝壳状断口；透明度跨度比较大，从透明到半透明的情况都有见；在光泽上鲜亮与淡雅并存，玻璃光泽；色彩以绿色为最常见，且在色彩上比较稳定。

马达加斯加红玛瑙圆珠

玛瑙珠、玉管组合饰件·西周

（9）玛瑙。玛瑙的矿物主要组成是石英，是一种天然玉石。主要化学成分也是二氧化硅，由隐晶质的石英组成。经常混合有蛋白石，有时体内形成条纹带。颜色鲜艳，质地坚硬，原石多呈现出扁圆形、不规则块状等，颜色丰富，红、黄、蓝、黑、棕、褐、绿等色彩，及衍生性色彩都有见，纯色少见，且珍贵，主要以渐变色彩为主。早期新石器时代就有使用，夏商周奴隶社会、秦汉至明清封建社会中都有使用，是珍贵的珠宝和人们的饰品。民国及当代，人们对其

绿玛瑙摆件

战国红算珠

更是钟爱。目前玛瑙已经成为天然玉石当中的重要门类，以红色最为贵重。如南红是玛瑙中的稀有品种，晶莹剔透，分外妖娆，为人们所喜爱，目前是以克论价。矿料出产于新疆、青海、甘肃、云南、四川等地，主要以云南保山料和四川凉山料为贵重。色彩以柿子红最为贵重，紫红、橙黄、玫瑰红、血红等色彩也都有见，是目前玛瑙市场的主流。

南红保山料镯（三维复原色彩图）

南红凉山料珠

南红保山杨柳料标本

（10）葡萄石。葡萄石的矿物主要组成
是一种天然玉石。葡萄石为参差状断口；其
色彩以黄绿等色为主，存在不断渐变的情况；
在透明度上，多以半透明为显著特征；通体闪
烁着非金属的玻璃光泽，光泽鲜亮，分外妖娆，
是人们非常喜欢的一种玉石品种，市场上很常见。

（11）汉白玉。汉白玉的矿物主要组成是方解石，是一种天然
玉石，但不是很高档的天然玉石。通常呈现出的是灰白等色，在色
彩上有一定偏色；微透明到不透明；光泽柔和。

（12）蓝田玉。蓝田玉的矿物主要组成是蛇纹石化大理石，是
一种天然玉石。蓝田玉是历史名玉，人们很早对其就有实用。其色
彩多变，常见米黄色、浅绿至绿色等，渐变性比较强，可以衍生很
多不同的色彩；从透明度上看，是微透明；产量很大，玉质一般，
只是历史名玉而已。但古代蓝田玉由于其具有历史价值，也是很多
人所孜孜以求的。

战国红摆件

南红云南保山杨柳料摆件

黄龙玉"表里通透"摆件

（13）黄龙玉。黄龙玉（黄玉髓）的矿物主要组成是石英，是一种天然玉石。微透明到透明；其主要化学成分为二氧化硅（SiO_2），含少量Fe_2O_3、Mn、K_2O、Cu等。不同矿物的含量决定黄龙玉色彩的差异，如黄色、红色、白色、黑色、灰色等，纯色及融合色彩共生，极为稀少伴随有水晶、玛瑙、玉髓、碧玉等；光性特征为隐晶质集合体，玻璃光泽。黄龙玉为宝石名称，不具有产地意义。宝石级的极品黄

黄龙玉"驾御饕餮"摆件

黄龙玉"蓬莱玉山"摆件

龙玉极为少见，其玉质细腻温润，油性光泽浓郁，堪比翡翠的硬度、和田玉的润度。黄色是天子之色、富贵之色，高贵、神秘，《史记·封禅书第六》："黄帝得土德，黄龙地螾见"。《周易·坤卦》："君子黄中通理，正位居体"。上溯上古，新石器时代黄色大型的玉器频见，由于开采能力有限，黄龙玉在历代一直处于稀少的局面，加之为帝王专用色彩，涉及者甚少，秦汉以降，直至明清，黄龙玉长期处于这一状态。明屈大钧《广东新语》："一卷蒸粟，黄润多姿"。清代梁九图《灵石记》："腊石最贵者色，色重纯黄，否则无当也"。黄蜡石即为黄龙玉，是其别称。而今盛世，开采能力增强，促使极品黄龙玉时有出现。鉴定时应注意分辨。

黄龙玉"双头鲍鱼"摆件

（14）硅孔雀石。硅孔雀石是一种天然玉石。参差状断口；从色彩上看以绿色等为主，偏色和串色的情况有见；在透明度上不是很乐观，基本上以不透明为显著特征；光泽淡雅，但绝不是黯淡，在光泽上多数通体闪烁着非金属的丝绢光泽。鉴定时注意分辨。

（15）菱锌矿。菱锌矿是一种天然玉石。菱锌矿在色彩上比较丰富，常见的主要有白、灰、黄、蓝、绿、粉等，以绿色和蓝色为贵重；在透明度上比较好，为半透明；光泽鲜亮，分外美丽。鉴定时应注意分辨。

（16）菱锰矿。菱锰矿是一种天然玉石。菱锰矿主要以粉红、玫瑰红等色为常见，渐变气氛较为浓重；基本不透明；光泽较为黯淡，以油脂光泽为主。是人们较为喜欢的一种玉石。

黄龙玉"籽种黄龙"摆件

青金石摆件

（17）青金石。青金石是一种天然玉石。以蓝色为基调，浅蓝、深蓝、青蓝等不同的色彩都存在，有的还带有一些不同的白点，总之在色彩上还是比较复杂；不透明；玻璃光泽；参差状断口。青金石是人们最为熟悉的玉石之一，器物以摆件和串珠等最为常见。鉴定时应注意分辨。

青金石摆件

青金石隔片

青金石摆件

青金石隔片

（18）苏纪石。苏纪石是一种天然玉石。在色彩上黄褐、浅粉红、黑色等常见，色彩变化比较丰富，色彩浓淡层次分明；在光泽上为树脂光泽；透明度比较好，但通透的情况不多见，多为半透明，非常的漂亮，很多人趋之若鹜。

（19）异极矿。异极矿是一种天然玉石。从色彩上看，以白、灰、浅黄等色多见，其他的色彩也有，总之在色彩上比较丰富；参差状断口到贝壳状的断口；光泽鲜亮与淡雅并存；透明度比较复杂，透明到半透明的情况都有见。

孔雀石手串

孔雀石镯（三维复原色彩图）

孔雀石鸡心坠

（20）白云母。云母是一种天然玉石，其色彩因所含矿物成分不同而发生变化。多为白色，也可呈浅红、浅黄、浅绿色，甚至褐色；透明度也比较好，从完全透明到半透明的情况都有见；晶体非常漂亮，美不胜收。白云母在色彩上不一定是纯白色，比较复杂，褐色、红色、无色等都有见，色彩变化区间比较大，色彩渐变性较强，光泽淡雅，为玻璃光泽到丝绢光泽，流光溢彩，光彩熠熠，分外美丽。

（21）锂云母。锂云母是一种天然玉石，因含锂而得名。在色彩上主要以紫色、黄绿色为多见，色彩渐变的气氛也是比较浓；光泽鲜亮，通体闪烁着非金属的淡雅光泽，熠熠生辉。

孔雀石算珠

（22）孔雀石。孔雀石为人们所熟知，是一种天然玉石。孔雀石为参差状断口；在色彩上以绿色为主，但色彩存在着渐变；通体不透明；有丝绢光泽，光泽淡雅柔和，非常漂亮。通常做成串珠等比较多，为人们所青睐。

（23）水镁石。水镁石是一种天然玉石。从色彩上看，主要以白、淡白、淡绿、红褐等色为显著特征，色彩变化比较丰富，特别是浓淡程度变化较多，且分明；在透明度上比较好，很多水镁石其实都是透明的。鉴定时应注意分辨。

虎睛石手串

虎睛石手串

（24）虎睛石。虎睛石的矿物主要组成是石英，是一种天然玉石。贝壳状断口；虎睛石在透明度上较为复杂，有见通透者，同时也有见半透的情况；光泽鲜亮与柔和相对应，多数通体闪烁着玻璃光泽，属非金属光泽的范畴。鉴定时应注意分辨。

虎睛石手串

东陵石青玉摆件

（25）鹰眼石。鹰眼石的矿物主要组成也是石英，是一种天然玉石。鹰眼石为贝壳状断口；光泽鲜亮与淡雅并存，通体为玻璃光泽；透明度比较复杂，从微透明到透明的情况都有见。是人们比较喜欢的一种玉石品种，鉴定时应注意分辨。

（26）东陵石。东陵石的矿物主要组成也是石英，是一种天然玉石。贝壳状断口；在透明度上特征比较复杂，从透明到微透明的情况都有见；光泽鲜亮与淡雅并存，柔和，细腻，致密程度比较高。东陵石颗粒比较细，是市场上比较常见的一种玉石，但并不是特别高档的玉石品种，产量较大，价格不高。

（27）青田石。青田石的矿物主要组成是叶蜡石、迪开石、高岭石，是一种天然玉石。青田石在色彩上有多种，如红、白、黄、黑等都有见；质地细腻，温润；光泽淡雅，柔和；微透明。由于原料近乎枯竭，十分珍贵，其收藏的价值很高。但市场上仿品也不少，在收藏时应先辨明真伪。

（28）水钙铝榴石。水钙铝榴石是一种天然玉石。从色彩上看以黄绿色为常见；透明度较高，为半透明；光泽鲜亮，玻璃光泽；贝壳状断口。是一种常见的玉石品种，不知多少人为之倾倒。

海纹石碟（三维复原色彩图）

东陵石青玉摆件

东陵石和合二仙白玉牌

海纹石单珠

（29）滑石。滑石是一种天然玉石。滑石色彩为浅黄色、灰白色、浅红色等，其他的色彩也有见；通透性不是很好，很多是不透明的；光泽比较好，为蜡状光泽；淡雅，柔和，手感十分温润，很多人喜欢。早在汉代六朝时期就常见滑石制作的器皿随葬在墓中。当代滑石制作的饰品也是比比皆是。但滑石并不属于高档玉石，相对来讲价格比较低，同时伴随而来的是资源也比较丰富。鉴定时应注意体会。

（30）针钠钙石。针钠钙石是一种天然玉石。针钠钙石多为无色，白色和灰白色等也有见，在色彩上有一定程度的偏色和串色，毕竟是自然之物，在色彩上的善变可以理解；参差状断口；光泽淡雅，受到人们的青睐。

（31）绿泥石。绿泥石是一种天然玉石。它也是一种河石，产于大渡河上游的深山幽谷之中，不知被河水冲刷了多少年，形成了其光滑圆润的外表，很多呈现出大型的卵状、块状。颜色多数以深绿色为基调；通体闪烁着淡雅的玻璃光泽，相当具有质感，很漂亮。鉴定时应注意分辨。

海纹石单珠

海纹石单珠

（32）白云石。白云石是一种天然玉石。主要成分为方解石，色彩为白色，故为白云石；光泽鲜亮；透明度很高，基本上为通透；光滑细腻，分外美丽，鉴定时应注意分辨。

（33）萤石。萤石是一种天然玉石，是一种会发光的矿物。通常为紫、绿等色，在色彩上渐变性比较强，色彩浓淡程度也不同，具有一定的复杂性；透明度很高；在黑夜里会发出荧光，通体闪烁着淡雅的非金属玻璃光泽。萤石多是集中产出，如河南洛阳地区就有质量不错的萤石。

岫玉璧·民国

岫玉璧·民国

　　（34）岫玉。岫玉是一种天然玉石。岫玉在色彩上以黄绿等色为常见，但具体色彩在这一基调之下变化很丰富；参差状断口；透明度较好，为半透明；多数通体闪烁着蜡状光泽，非常漂亮。是历史名玉，在新石器时代的红山文化时期人们就使用岫玉制作了大量的玉器。岫玉在市场上比较常见，器物如花片、香薰、印章、壶、镯子、龙牌、玉璧、山子、把件、挂件、串珠、项链、平安扣、隔片、隔珠、扳指、茶壶、茶杯、盖碗、貔貅、牛、生肖牌、大象、金蟾蜍、麒麟、宝塔、龙龟献寿、福寿连连吊坠、十字架、关公、龙等。是目前除和田玉之外较为主流的玉石之一，深受人们青睐。

岫玉璧·民国

（35）查罗石。查罗石的矿物主要组成是紫硅碱钙石，是一种天然玉石。从色彩上看，以紫色为常见，在紫色当中常常伴随有黑色、白色等的斑点，与玉色共为一体；纤维状结构，光泽淡雅，柔和，光泽从玻璃光泽至蜡状光泽都有见，很多人非常喜欢。鉴定时应注意分辨。

（36）钠长石玉。钠长石玉是一种天然玉石。钠长石玉在色彩上以灰绿、灰白、白色为常见，无色的情况也很多；光泽淡雅，柔和，油脂光泽至玻璃光泽，亦真亦幻，美妙绝伦。鉴定时应注意分辨。

（37）蔷薇辉石。蔷薇辉石的矿物主要组成是蔷薇辉石、石英，是一种天然玉石。从断口上看为贝壳状；色彩以粉红色为主；透明度较好，为半透明；通体闪烁着玻璃光泽，至真至纯，美不胜收。是人们十分喜欢的一种玉石品种。

（38）独山玉。独山玉的矿物主要组成是斜长石、黝帘石，是一种天然玉石。透明度从微透到透明的情况都有见；通体闪烁着非金属的玻璃光泽；贝壳状断口。独山玉是历史名玉，早在新石器时代就有见使用。目前市场上常见有：把件、手串、貔貅、八骏马、带扣、观音、弥勒、佛像、挂件、摆件、财神、钟馗、婴戏、寿星、碗、盘、碟、茶碗、茶盏、烟嘴、项链、佛头、牌饰、烟嘴、平安双鱼等。特点是多色，多种色彩集中于一件器物之上，看起来亦真亦幻，分外美丽。

独山玉蝴蝶·清代

独山玉蝴蝶·清代

独山玉蝴蝶·清代

优化绿松算珠

（39）鸡血石。鸡血石的矿物主要组成是辰砂、迪开石、高岭石、叶蜡石、明矾石。一般来讲，"血"的矿物成分是辰砂，"地"是迪开石、高岭石、叶蜡石、明矾石等，是一种天然玉石。其"血"的形状多种多样，实际上并无规律，只是从形状上人们常将其分为条血、浮云血等。血色浓深，深入胎骨，最为美丽；光泽淡雅，十分珍贵。目前市场上常见。

（40）田黄。田黄的矿物主要组成是迪开石、高岭石、叶蜡石、珍珠陶土，是一种天然玉石。田黄是寿山石里最优的品种，色彩犹如蜂蜜般，看到似闻到蜜香；光泽饱满，油性十足，淡雅，柔和；手感光滑、细腻。传说是乾隆皇帝的最爱，多少文人墨客为之倾倒，亦真亦幻，美妙绝伦。

（41）阳起石。阳起石是一种天然玉石，成分为硅酸盐类矿物。阳起石光泽鲜亮到淡雅都有见，通体闪烁着非金属的玻璃光泽；从透明度上看具有一定的复杂性，从透明到不透明的情况都有见；从色彩上看以白色、浅灰等为常见，色彩渐变比较浓郁。鉴定时应注意分辨。

（42）绿松石。绿松石是一种天然玉石。颜色多为绿色、蓝色等；不透明；蜡状光泽至玻璃光泽。绿松石常见的器物及造型主要有手串、项链、吊坠、牌、平安扣、老料随形、三通、单珠、筒珠、隔片、隔珠、山子、把件、戒指、佛头、观音、弥勒、佛像等。由此可见，绿松石的造型种类十分丰富，在鉴定时我们应注意这方面的内容。

优化绿松算珠

优化绿松石执壶（三维复原色彩图）

（43）硅硼钙石。硅硼钙石是一种天然玉石。硅硼钙石从色彩上看以白、浅绿、褐、灰色等为常见，无色者也有见，由此可见，其在色彩上变化是异常丰富的，组合色彩、串色、偏色、渐变的情况都有见；光泽鲜亮到淡雅的情况都有见，多数通体闪烁着非金属的玻璃光泽；透明度也是比较复杂，从透明到半透明的情况都有见。

（44）羟硅硼钙石。羟硅硼钙石是一种天然玉石。羟硅硼钙石在色彩上以白色和灰白等色为主；多数通体闪烁着非金属的淡雅玻璃光泽。

（45）方钠石。方钠石是一种天然玉石。参差状断口；从色彩上看多为蓝色，在色彩上渐变的气氛有见；从通透性上看比较不透明；光泽黯淡，具非金属的玻璃光泽；其色彩的淡雅柔和是许多人喜欢它的原因，亦真亦幻，使人心旷神怡。鉴定时应注意分辨。

（46）黑耀石。黑耀石的矿物主要组成是天然玻璃，是一种天然玉石。从色彩上看，以黑色或黑褐色为多见，其他的渐变色彩也有见，但都与基调色彩比较接近；从透明度上看，透明到半透的情况都有见；通体闪烁着非金属的玻璃光泽，熠熠生辉，非常的漂亮，受到人们的青睐。目前市场上比较常见。

黑曜石手串

黑曜石手串

（47）玻璃陨石。玻璃陨石的矿物主要组成是天然玻璃，是一种天然玉石。玻璃陨石在色彩上特征比较明确，以褐色、深褐色、墨绿色、绿色等为多见，其他的色彩也有见；透明度特征比较复杂，从透明到半透的情况都有；光泽鲜亮与淡雅并存，通体闪烁着非金属的玻璃光泽，分外妖娆，使人心旷神怡。鉴定时应注意分辨。

（48）赤铁矿。赤铁矿是一种天然玉石。赤铁矿在色彩上以灰色为主；完全不透明；贝壳状断口；闪烁着金属光泽。其实，赤铁矿更多的功能是一种矿石，很多人喜欢用其直接作为摆件使用。

黑曜石貔貅

第三节　有机宝石

（1）珍珠。珍珠是一种天然有机宝石，包括天然珍珠和养殖珍珠。天然珍珠包括天然海水珍珠和天然淡水珍珠；养殖珍珠也有海水养殖珍珠和淡水养殖珍珠。珍珠在色彩上比较丰富，白色、黑色、粉红等色都有见，其他色彩也有见。从透明度上看特征很明确，所有的珍珠都是不透明的；光泽鲜亮，融合，为珍珠光泽。总之，珍珠之美，有目共睹，无论在古代还是当代，都是重要的珠宝品类，特别是好的珍珠为藏家孜孜以求。

珍珠标本

925 银嵌珍珠戒指

金色珍珠标本

（2）珊瑚。珊瑚是一种天然有机宝石。珊瑚的概念比较清晰，由珊瑚虫分泌出的外壳组成。珊瑚虫是一种圆筒状的腔肠动物，为无脊椎的低等动物，主要食物为海洋中的浮游生物。这些浮游生物在海洋中到处都是。珊瑚虫一端固定在已形成的珊瑚礁上，另外一端有口，口有圈形触手，上面有刺细胞，触手可以捕捉食物。而珊瑚就是由珊瑚虫所分泌出的石灰质所形成，印度洋、太平洋、大西洋等的热带、亚热带浅海区有众多的珊瑚生长。中国、日本、阿尔及利亚、突尼斯、摩洛哥、意大利等都有较好的珊瑚产出，特别是中国台湾所产的珊瑚，无论在数量还是质量上均居世界第一。

莫莫红珊瑚玉米穗挂件

莫莫红珊瑚元宝

红珊瑚阿卡枝

　　（3）琥珀。琥珀是一种有机宝石，也是一种古老的化石，由松科、柏科植物的树脂，在空气中硬化而形成。有的琥珀在地球上已经存在了千万年乃至上亿年。欧洲、中美洲、中东等地区都发现了一亿年以上的琥珀。由于松科、柏科植物树脂在空气中硬化的速度比较快，有时只要一滴就可以使小昆虫挣扎不得，被永远包裹在里面，蜘蛛、苍蝇、蚊虫、蜗牛等都常见，同样一些植物也常被包裹在里面。琥珀依据不同的分类标准，可以被分为各种类型，较为常见的是血珀、金珀、骨珀、花珀、蓝珀、虫珀、香珀、翳珀、石珀等。琥珀的产地非常多，我国主要产于抚顺，属于矿珀，有时可见里面包裹的动植物化石。另外，河南南阳西峡也产琥珀，但具有经济意义的宝石级琥珀较少，主要为翳珀，形状为饼状、团状、水滴状等。云南永平保山也有少量产出。

　　由于国内原料缺少，所以目前市场上的琥珀，基本上以进口料为主，以波罗的海沿岸国家为主，如俄罗斯、乌克兰、法国、德国、英国、罗马尼亚、意大利、波兰等国，特别是俄罗斯的产量最大，基本上占到整个琥珀量的92%以上。另外，中美洲、中东、亚洲等也都是琥珀出产地。中美洲的以多米尼加最为著名，其他的如墨西哥、智利、阿根廷、哥伦比亚、厄瓜多尔、危地马拉、巴西等国都产琥珀。亚洲的缅甸也是重要产区。而我国目前进口的琥珀主要产地是波罗的海沿岸国家及缅甸。

血珀、金珀串珠

琥珀平安扣

（4）硅化木。硅化木是一种天然有机宝石。从色彩上看，黄褐、红褐、灰白、灰黑等都有见，其他的色彩也有见，总之色彩比较复杂，出现任何的色彩都不奇怪；光泽鲜亮和淡雅并存，玻璃光泽；透明度也是比较复杂，从透明到半透明，半透明到微透明的情况都有见，可见区间跨度之大。硅化木光怪陆离为人们所喜爱，目前市场上常见。

（5）龟甲。龟甲是一种天然的有机宝石。从色彩上看为黑褐色，但是色彩微观的变化很丰富，有各种各样的衍生色彩，以及偏色等都有见。这是可以理解的，因为龟在生长的过程当中所处的环境很复杂，所以在微观色彩上有什么样的色彩都很正常，不必太在意。总之，龟甲不透明，手感光滑，是人们十分喜爱的一种有机宝石。

砗磲摆件

砗磲手串

煤精绿松石串饰·西周

（6）砗磲。砗磲是一种相当大的贝壳，是天然有机宝石。砗磲整个壳子的厚度也是相当厚，可以制作各种工艺品。古代和当代都非常喜欢砗磲这一有机宝石。器物及造型如项链、手串、串珠、念珠、围棋、鼻烟壶等都常见。砗磲非常光滑，润泽，温润，一旦接触，就爱不释手。

（7）煤精。煤精是一种天然有机宝石，其材料名称是褐煤。从色彩上看，主要以黑色为基调，色彩渐变的情况也有，但幅度不大，如渐变成为墨色；从透明度上看，不透明；光泽淡雅，为非金属的油脂光泽；贝壳状断口。在古代被广泛地应用，主要是做一些项链、首饰之类的器物。如河南三门峡西周虢国墓地 M2001 号国君大墓就曾出土过一件煤精串饰。当代也常见各种各样的煤精饰品。

（8）象牙。象牙是一种天然有机宝石。象牙的色彩为白色、乳白色等，但色彩的渐变也是比较浓郁，有的时候略泛黄也有可能；从透明度上看，不透明；光泽淡雅、柔和，非常漂亮。象牙制品十分珍贵，自古受到人们的青睐，常见的器物及造型有笏板、水滴、山子、镇纸、牌、臂搁、如意、扇、毛笔等。由此可见，象牙的造型种类十分丰富，从这些造型上也可见人们对于象牙制品的青睐。

第一节　逛市场

一、国有文物商店

珠宝的概念比较宽泛，包含天然宝石、天然玉石、天然有机宝石等，涵盖古代和当代，国有文物商店收藏的珠宝具有其他艺术品销售实体所不具备的优势：一是实力雄厚；二是古代文物数量较多；三是中高级鉴定专业鉴定人员多；四是在进货渠道上层层把关；五是国有企业集体定价，价格不会太离谱。

茶晶碗（三维复原色彩图）

黄龙玉单珠

黄晶摆件

国有文物商店是购买珠宝的好去处，也是国家允许售卖文物的重要市场之一；另外，国有文物商店不仅有销售部，而且还有收购部门，收购和销售的价格比较公道，一般不必担心会挨宰。基本上每一个省都有国有文物商店，是文物局的直属事业单位之一。下面我们具体来看一看表4-1。

表4-1 国有文物商店珠宝品质状况

名称	时代	品种	数量	品质	体积	检测	市场
珠宝	高古	极少	极少	优／普	小	通常无	国有文物商店
	明清	稀少	少见	优／普	小器为主	通常无	
	民国	稀少	少见	优／普	小器为主	通常无	
	当代	多／少	多／少	优／普	大小兼备	有／无	

925银链莫莫红珊瑚球吊坠

青金石摆件

925 银链莫莫红珊瑚球吊坠

金色珍珠标本

由表 4-1 可见，文物商店内的珠宝在时代特征上比较多，古代和当代的都有，给我们选择古代珠宝艺术品提供了便利条件。

从品种上看，文物商店内古代的珠宝极少见到，主要以明清和民国的为多见，品种总的来看比较少，以传统的和田玉、玛瑙、琥珀、蜜蜡、珍珠、珊瑚等为主。在当代还是有可能买到古代的珠宝；明清和民国时期的珠宝虽然是稀少，但是有一些；当代珠宝的种类和数量都特别多，文物也有一些，不过数量较少。

从检测上看，文物商店内的珠宝通常很少去做物理方面的检测，也没有什么检测报告，但是由于大多经过文物专家的鉴定，所以在品质上还是比较放心的。

珍珠标本

925 银嵌珍珠吊坠

珍珠标本

紫罗兰翡翠四季豆

南红保山料碟（三维复原色彩图）

二、大中型古玩市场

大中型古玩市场是珠宝销售的主战场，如北京的琉璃厂、潘家园等，以及郑州古玩城、兰州古玩城、武汉古玩城等都属于比较大的古玩市场，集中了很多珠宝销售商，像北京报国寺只能算作是中型的古玩市场。下面我们具体来看一下表4-2。

表4-2 大中型古玩市场珠宝品质状况

名称	时代	品种	数量	品质	体积	检测	市场
珠宝	高古	极少	极少	优／普	小	通常无	大中型古玩市场
	明清	稀少	少见	优／普	小器为主	通常无	
	民国	稀少	少见	优／普	小器为主	通常无	
	当代	多／少	多／少	优／普	大小兼备	有／无	

橄榄石碟（三维复原色彩图）

南红凉山料手链

清代翡翠吊坠

由表 4-2 可见，从时代上看，这些大中型古玩市场在各个时代的珠宝都有见。但从数量上看，古代珠宝比较稀少，而当代数量比较多。当然，从种类上看也是这样，仅天然玉石的种类就有翡翠、和田玉、欧泊、白欧泊、黑欧泊、寿山石、田黄、青田石、水镁石、苏纪石、异极矿、云母、白云母、锂云母、火欧泊、玉髓、玛瑙、黄龙玉、蓝玉髓、绿玉髓（澳玉）、木变石、虎睛石、鹰眼石、石英岩、水钙铝榴石、滑石、硅硼钙石、羟硅硼钙石、方钠石、赤铁矿、天然玻璃、黑耀岩、玻璃陨石、鸡血石、针钠钙石、绿泥

黑曜石手串

石榴石串珠

虎睛石手串

红玛瑙摆件

海纹石镯（三维复原色彩图）

石、东陵石、蛇纹石、岫玉、独山玉、查罗石、钠长石玉、蔷薇辉石、阳起石、绿松石、青金石、孔雀石、硅孔雀石、葡萄石、蓝田玉、菱锌矿、菱锰矿、萤石等。可见，当代珠宝的种类已不是古代所能够同日而语的了。

古玩市场中销售珠宝的店铺林立，但店铺大小不一，所经营的珠宝品级不一。有经营数百年之久的沧桑老店，如荣宝斋，也有昨日新开的古董店；有收藏各色珠宝的大店，也有收藏散碎珠宝的小店；当然也有不入流的珠宝店。总之是各种各样的珠宝在这里都有，你想要什么，基本上都能买到，但真伪需要自己辨别。

优化绿松石隔片

孔雀石珠

青金石摆件

　　从检测上看，当代珠宝有的有简单的检测，但古代的通常没有。这是因为很多检测都是有损检测，可能会损坏古代珍贵的珠宝。因此购买时要慎重辨识珠宝。从价格上看，也是极为不一，有的仅需要几元钱一克拉，而有的则需要数百上千元一克拉，可谓是有天壤之别。所以，无论你在哪里买珠宝，如果你不按照珠宝的品质标准来严格区分，还真有可能损失很大。

孔雀石珠

橄榄石摆件

虎睛石手镯（三维复原色彩图）

砗磲手串

三、自发形成的古玩市场

这类市场三五户成群，大一点的有几十户。这类市场不很稳定，有时不停地换地方，但却是我们购买珠宝的好地方。我们具体来看一下表4-3。

表 4-3 自发古玩市场珠宝品质状况

名称	时代	品种	数量	品质	体积	检测	市场
珠宝	高古						自发古玩市场
	明清	稀少	少见	普 / 劣	小器为主	通常无	
	民国	稀少	少见	普 / 劣	小器为主	通常无	
	当代	多 / 少	多 / 少	优 / 普	大小兼备	通常无	

孔雀石手串

孔雀石碗（三维复原色彩图）

　　由表 4-3 可见，这样的市场在时代上古代珠宝不占优势，明清和民国时期有一些，但也是真伪难辨。不过它总是存在于城市的某个角落里，淘货全凭自己的眼力，多是当代的一些珠宝等。另外，珠宝品质也是不一，被小贩们用各种故弄玄虚的办法包裹之后进行销售。许多石头直接被偷换概念当成珠宝来兜售。但是这类市场当中，有一些产地市场应引起我们的重视，如近年来黄龙玉产地就自发形成了一些小的市场，一些村口的农户家中就是小的市场。这些小的市场还是有一些好货，假货也不多，值得一看，但就是交通不太方便。几乎每一种珠宝都有这样的最初市场，我们不妨在旅游假日来临之际去看一看，可能会有收获。

孔雀石算珠

黄龙玉摆件

黑曜石貔貅

茶晶珠

四、大型商场

大型商场内也是珠宝销售的好地方。因为珠宝本身就是奢侈品，同大型商场血脉相连。大型商场内的珠宝琳琅满目，各种珠宝应有尽有，在市场上占据着主要位置。下面我们具体来看一下表4-4。

表4-4 大型商场珠宝品质状况

名称	时代	品种	数量	品质	体积	检测	市场
珠宝	高古						大型商场
	当代	多／少	多／少	优／普	大小兼备	通常无	

虎睛石执壶（三维复原色彩图）

青金石执壶（三维复原色彩图）

优化绿松石镯（三维复原色彩图）

红水晶碟（三维复原色彩图）

黄龙玉串珠

由表 4-4 可见，从时代上，大型商场内的珠宝销售主要以当代珠宝为主，不销售古代珠宝。这是因为大多数大型商场没有销售古代文物的资质，这不是它们的销售范围。从品种上看，高级商场内的珠宝品种很多，有的大商场可以达到数百种，即使没有货也可以预约定制等，总之你想要什么就会有什么。从器物及造型上看也很齐全，如项链、佛珠、手串、雕件、山子、戒指、耳环等都有见。

在品质上，大商场内的珠宝品质有保障，一些名牌的珠宝专卖商本身信誉比较好。但品质根本还是需要自己来看，因为这不像是真伪，会有一个检测证书可以辨别。从真伪上看，大型商场内的珠宝多数都有检测证书，从物理性质上对所销售的珠宝有一个定论，就是珠宝性质，珠宝名称。总的来看，大型商场是当代珠宝销售的主要市场。

莫莫红珊瑚筒珠

莫莫红珊瑚摆件

925 银莫莫红珊瑚粉色雕花耳钉

莫莫红珊瑚随形筒珠

五、大型展会

大型展会，如珠宝订货会、工艺品展会、文博会等已成为珠宝销售的新市场。下面我们具体来看一下表 4-5。

表 4-5 大型展会珠宝品质状况

名称	时代	品种	数量	品质	体积	检测	市场
珠宝	高古						大型展会
	明清	稀少	少见	优／普	小器为主	通常无	
	民国	稀少	少见	优／普	小器为主	通常无	
	当代	多／少	多／少	优／普	大小兼备	通常无	

莫莫红珊瑚标本

琥珀随形摆件

优化绿松石隔片

青金石隔片

由表 4-5 可见，大型展会上主要以当代珠宝为主。这些珠宝中包括了进口和国产珠宝。一些国外的展商也是跟着展会转，展会的影响力不容忽视。展会上的珠宝在品质上不乏优良者，但更多的是普通的产品。在价格上可以砍价，砍价的幅度与购买量挂钩。如果是批发，价格会相当便宜。但如果是零售，价格很难谈下来。从真伪上看，一般情况下大型展会上检测证书很少见，如琥珀、蜜蜡原石等都是大量地堆一处。因为是批发性质，所以不会像大商场一样很细致。真伪和品质大多需要自己来判断。

金沙石手串

六、网上淘宝

网上购物近年来成为时尚，同样网上也可以购买珠宝。上网搜索会出现许多销售珠宝的网站。下面我们具体来看一下表 4-6。

表 4-6 网络市场珠宝品质状况

名称	时代	品种	数量	品质	体积	检测	市场
珠宝	高古	极少	极少	优／普	小	通常无	网络市场
	明清	稀少	少见	优／普／劣	小器为主	通常无	
	民国	稀少	少见	优／普／劣	小器为主	通常无	
	当代	多／少	多／少	优／普	大小兼备	通常无	

黄龙玉随形摆件 "通天礼地——黄龙玉钺"

琥珀随形摆件

　　由表 4-6 可见，网上购买珠宝非常便利。从时代上看，各个时代的珠宝都有见，从数量上看主要以当代为主。但是，网上淘宝有很多弊端，如只能看照片，不能接触实物。因此，如果需要在网上购买，还是选择较大型和知名度高的网站，这样不至于买到不靠谱的产品。

橄榄石碟（三维复原色彩图）

莫莫红珊瑚吊坠

七、拍卖行

珠宝拍卖是拍卖行传统的业务之一，具体我们来看一下表 4-7。

表 4-7 拍卖行珠宝品质状况

名称	时代	品种	数量	品质	体积	检测	市场
珠宝	高古	极少	极少	优／普	小	通常无	拍卖行
	明清	稀少	少见	优良	小器为主	通常无	
	民国	稀少	少见	优良	小器为主	通常无	
	当代	多／少	多／少	优／普	大小兼备	通常无	

莫莫红珊瑚花卉雕件

由表 4-7 可见，拍卖行的珠宝拍卖 时，古代和当代都有见，种类也很齐全，而且珠宝专场的拍卖会相对集中于某一类的珠宝，这样更有利于对比价格。但拍卖行并不对珠宝的真伪进行保真，拍卖只是一个平台，真伪全凭自己识别，且拍卖主要以高端产品为主。近些年，珠宝不断出现在不同的拍卖场，取得了很好的成绩。

阿卡珊瑚碗（三维复原色彩图）

八、典当行

典当行也是购买珠宝的好去处。典当行的特点是对来货把关比较严格，一般都是死当的珠宝作品才会被用来销售。具体我们来看一下表4-8。

表 4-8 典当行珠宝品质状况

名称	时代	品种	数量	品质	体积	检测	市场
珠宝	高古	极少	极少	优／普	小	通常无	典当行
	明清	稀少	少见	优良	小器为主	通常无	
	民国	稀少	少见	优良	小器为主	通常无	
	当代	多／少	多／少	优／普	大小兼备	通常无	

石榴石手镯（三维复原色彩图）

黄龙玉戒面

由表 4-8 可见，典当行经过了内部专业的流程，假货的可能性比较小。而且，典当行的优势是价格比较低，因为一般典当的价格是市场价的一半，甚至会更低一些。所以，典当行在二次销售的时候价格上有一定优势。但其来源不是进货，而是死当，导致了其销售种类的不可预测性，这是典当行的不足之处。

黄龙玉貔貅

和田青玉手串

第二节　评价格

一、市场参考价

　　珠宝在价格上升值很快，二十年前百元一克或克拉的珠宝，今天可能需要上万元。举两个较为典型的例子：传统和田玉白玉，在 1978 年，大概每公斤就是三十到五十元，在 1980 年的时候就涨到一百多元，到 1996 年的时候已达到七八千元，到 2000 年的时候就已经过万。那么我们知道，在现在可能要几十万元到上百万元。由此可见，当今社会就是一个盛世收藏的社会，相信古玉器还会具有更大的升值潜力（姚江波，2011 年）。另外一个例子就是黄龙玉，黄龙玉是当代发现的一个玉种，2010 年才登上国家宝玉石名录。在 2000 年左右，黄龙玉一车的价钱也就是几千元，平均下来每公斤几元钱，但是现在的价格优者每公斤几千数万元，上涨了千倍都不止。

　　宝玉石名录上的每一种珠宝在价格上都有这样一个神奇的故事。因为珠宝本身就是自然界的一种物质，在人们没有赋予其价值之前，所有珠宝的价值理论上都是零，这一点我们应能理解。但是，一旦人们赋予珠宝价值，珠宝也就具有了价值，并在市场上有参考价格。下面我们就来具体看一下。

水晶摆件

黄龙玉粉色桶珠

和田青玉兔·西周

1.古代珠宝

古代珠宝以明清时期为主，特别是清代为多见，是珠宝价格上的高地，这与其具有文物的价值有关。其器物及造型比较多，如朝珠、念珠、把件、随形山子、花插、笔架、镇纸、蝙蝠、串珠等都常见，总之各种各样的古代珠宝都有见，其价值非常之高。从计价上看，古代珠宝计价方式以单件为主，加价的原则是历史研究价值、艺术价值之和，一件珠宝几万甚至几十万的情况很常见。当然，古代珠宝的计价方式也有以称重计量，多少克拉多少钱的情况。从目前的市场参考价来看，古代珠宝的市场价格一直是在上升。

2.当代珠宝

从进口珠宝上看，当代珠宝在品质上比古代珠宝更有优势，产品多，选择性更大，品质极高，在价格上也是不断上扬。

从国产珠宝上看，我国的珠宝资源十分丰富，如：珊瑚、珍珠、琥珀、蜜蜡、绿松石、和田玉、玛瑙、红宝石、蓝宝石、橄榄石、水晶等。而且我国大多数地区都有珠宝产出，只是品质优劣不一，但目前价格基本上都是一路上扬。

绿幽灵吊坠

青金石碟（三维复原色彩图）

从体积上看，珠宝的体积特别重要。我们知道，红宝石、蓝宝石、钻石、橄榄石等，体积大小决定其价格。如橄榄石体积小者几十元每克拉，看起来都不像是珠宝的价格；但体积大者，其价格往往也都是天价，价格可以相差数十上百倍。因此，同品质的珠宝体积大者为贵。

珠宝的参考价格比较复杂，下面让我们来看一下珠宝主要的价格。但是，这个价格只是一个参考，因为本书的价格是已经抽象过的价格，是研究用的价格，实际上已经隐去了该行业的商业机密，如有雷同，纯属巧合，仅仅是给读者一个参考而已。

橄榄石摆件

青金石摆件

方解石猫眼夜明珠 26000 万～ 48000 万元。

海蓝宝石 16000 万～ 28000 万元。

红宝石摆件 6600 万～ 6800 万元。

红宝石配钻石项链 6600 万～ 8800 万元。

钻石项链 5600 万～ 6800 万元。

夜明珠 4600 万～ 9800 万元。

翡翠朝珠 4600 万～ 9800 万元。

玻璃种翡翠观音 4600 万～ 5800 万元。

翡翠钻戒、项链 4600 万～ 6800 万元。

钻石吊坠 3600 万～ 3800 万元。

祖母绿挂坠 2600 万～ 5800 万元。

祖母绿及钻石项链 2600 万～ 4800 万元。

天然珍珠及钻石项链 2600 万～ 3800 万元。

全美钻石 2600 万～ 2800 万元。

全美红宝石 2600 万～ 2800 万元。

蓝宝石配钻石项链 2600 万～ 3800 万元。

二、砍价技巧

砍价是一种技巧，但并不是根本性的商业活动，只能起到辅助的作用，而不能将其作为商业活动的根本，是在确定已经要购买的情况下与对方讨论价格的过程，但只有找出弱点才能抡锤砍价。需要提醒的是，不重视珠宝的质量，一味地重视砍价是不可取的。

从识别优劣上看，识别优劣在砍价技巧当中十分重要，因为珠宝的价格主要是由其品质所决定，而品质就是优劣。有的时候，珠宝品质差别并不大，但是即使有一点点品质差别，对于珠宝的价格影响都是巨大的。因此，我们在购买珠宝的过程当中具备识别优劣的能力，必将成为砍价的利器。

从优化上看，珠宝以天然为主，识别优化珠宝特别重要，如改色珠宝、改变匀净程度等，如果能够找到确凿的证据，则会在价格谈判上占尽先机。

从精致程度上看，珠宝的精致程度是判断珠宝价格的标准，如果能够找到商家在精致程度标准上的破绽，显然是珠宝砍价的利器。

总之，珠宝的砍价技巧涉及材质、造型、产地、纹饰、色彩、琢磨、匀净程度等诸多方面，从中找出缺陷，必将成为砍价利器。

优化绿松算珠

优化绿松算珠

粉晶吊坠

优化绿松石隔片

黑曜石貔貅

第三节　懂保养

一、清 洗

　　珠宝清洗较为复杂，因为珠宝的种类比较多，每一种珠宝的成分不一样，所以清洗方法也不尽相同。应掌握每一种珠宝的特性，在制定预案的基础上再对珠宝进行清洗。比较珍贵的珠宝应送专业研究或者商业机构进行清洗。

　　一般情况下，珠宝的污染主要来自于化学物质，如不干净的水，洗澡用的沐浴露、洗发膏等都可能含有对珠宝不利的化学物质，会破坏珠宝表面的结构，使得珠宝失去光泽。另外，人们在佩戴珠宝的过程当中，要避免使珠宝受到刺激，在平时洗漱时应将珠宝手串卸下来。但是，珠宝不可避免地需要清洗。刚刚买回来的珠宝，不能像洗菜一样在水龙头上直接冲洗，应该首先了解其特性。

孔雀石珠

孔雀石珠

黑曜石手串

二、盘　玩

　　某些珠宝通过盘玩可以产生包浆，可以使得珠宝更加温润，给人以美的享受。一般而言，收藏者通过佩戴珠宝，就可以使珠宝更加温润，这就是盘玩，也是人们所说的文盘。另外，还有武盘，珠宝武盘的方法与文盘刚好相反，武盘就是不停地揉搓，使其很快形成包浆。这种盘磨的方法经常应用于商业，有批量生产包浆之嫌。但珠宝的承受力，以及盘磨的方法都有一定的规律，如不可揉搓过度，用力过猛等都有可能对珠宝造成伤害。总之，应用心盘磨珠宝，文盘和武盘相结合是比较好的方法。因为盘玩是一个"养性"的过程，体现的是收藏者内心的各种活动，即用心去体会珠宝之美，达到心的照应，陶冶情操。

　　对于珠宝而言，其实也只是部分珠宝适合盘玩，如琥珀、蜜蜡、和田玉、翡翠等；而像红宝石、蓝宝石、钻石等，其实盘磨并不能起到好的作用。

三、禁　忌

珠宝把玩过程当中有许多禁忌。防止化学反应是盘玩的重要禁忌之一。如在盘玩的过程当中急于求成，使用一些化学试剂抛光等，这是一种非常危险的现象，可能会对珠宝造成伤害。从防止高温上看，珠宝并不能在高温中独善其身，如大于 40℃的高温就会对其造成伤害，珠宝中油的挥发就会加快。从防止暴晒上看，珠宝最忌暴晒，在太阳下暴晒会使珠宝开裂，品质下降等。但正常佩戴，一般的光照，则不会对珠宝的品质造成影响。

珠宝在盘玩时还应注意防止污染，如指甲油、肥皂水、强酸等都不能接触珠宝，同时在不佩戴时应注意密闭保养。

青金石串珠

石榴石串珠

南红保山杨柳料标本

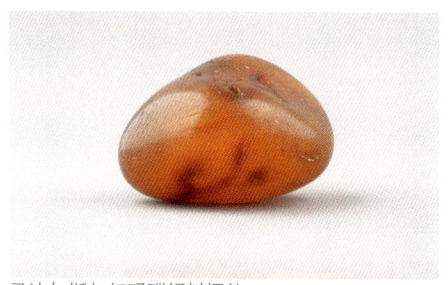
马达加斯加红玛瑙籽料摆件

四、日常维护

收藏到珠宝的第一步是进行测量，对珠宝的长度、高度、厚度等有效数据进行测量。目的很明确，即是对珠宝进行研究，以及防止被盗或是被调换。第二步是进行拍照，如拍摄正视图、俯视图和侧视图等，给珠宝保留一个完整的影像资料。从建卡上看，珠宝收藏当中很多机构，如博物馆等，通常给珠宝建立卡片。卡片的内容首先是名称，包括原来的名字和现在的名字，以及规范的名称；其次是年代，就是这件珠宝的制造年代、考古学年代；还有质地、功能、工艺技法、形态特征等的详细文字描述。这样我们就完成了对古代珠宝收藏最基本的工作。但如果是个人，很有可能会省略掉这项工作。

从建立账册来看，机构收藏的珠宝，如博物馆，通常在测量、拍照、卡片、包括绘图等完成以后，还需要入国家财产总登记账。通常账册有藏品的总登记账和分类账两种。总登记账是必须建立的，要求一式一份，不能复制，主要内容是将文物编号、登记，内容有总登记号、名称、年代、质地、数量、尺寸、级别、完残程度，以及入藏日期等。总登记账要求有电子和纸质两种，是文物的基本账册。藏品分类账也是由总登记号、分类号、名称、年代、质地等组成，以备查阅。但对于普通的收藏者而言，可能就不需要这些，因为收藏的珠宝非常少，但可以根据数量而决定有无建立账册的必要。

从防止磕碰上看，珠宝在保养上防止磕碰是一项很重要的工作。因为一些珠宝质地较脆，掉在地上很容易摔裂，一般情况下都是独立包装，避免同其他器皿碰撞。从防止划伤上看，珠宝在保养中应注意防止划伤，一般的金属锐器都能在珠宝上划出伤痕。从相对湿度上看，一般情况下保存珠宝的相对湿度应保持在50%～70%之间，不能太干燥。

仿红山文化玉龙·西周晚期

第四节　市场趋势

一、价值判断

1.研究价值

（1）历史载体。珠宝的形成需要数百上千年的时间，对珠宝本身来讲就具有相当长的历史时期，见证了岁月的沧桑风雨。再者，古代珠宝制品的年代通常也是比较长。汉代就有见，唐宋以降，直至明清，特别是明清时期的珠宝传世品很常见，各种各样的造型承载了当时工匠的所思所想，承载着众多的历史信息，具有极高的研究价值，影响深远，是复原人类历史的依据。

（2）工艺研究。珠宝无论古代还是当代都十分珍贵，有着相当高的艺术价值。工匠们对于珠宝的制作特别讲究，基本上代表了各个时代最高的工艺技术水准，有着隽永的外形，凝炼的纹饰，最优的材质，同时期流行的色彩，最美的香韵，代表工艺的弧度与规整等，对于工艺研究有着极为重要的价值。

海纹石单珠

2. 艺术价值

（1）内敛艺术。珠宝在表面上千变万化，但在艺术上的成就极高。珠宝的温润给人们的视觉冲击力很大，体现出了人们最为内敛的心。多数珠宝都是精美绝伦，艺术价值很高，大有只可意会不可言传之感。

925 银嵌珍珠吊坠

（2）选材艺术。珠宝制品在选材上几乎无一例外的都是极尽心力。珠宝的材质本身各种各样，形状也最为复杂，再没有一种材质在造型上有珠宝这么神奇了。不做修饰、形状各异，给人以无限想象的空间，有的形同山子，有的形同生肖，而珠宝制品就是在这些原始造型之上稍作改动，贪巧夺天工之韵。如顺着一个形同高僧的材料雕刻一尊佛像等，加之人们对于珠宝一丝不苟的态度，无论是古代还是当代，珠宝都达到了相当高的水平，给人以无限的艺术享受。

（3）纹饰艺术。珠宝以纹饰取胜。许多珠宝上都有纹饰，纹饰多以简洁为主，寥寥几笔就可以勾勒出万千世界。以写意为主，写实为辅，每一个笔道都是线条流畅、构图合理。这种装饰纹饰的方法一直持续到当代。而由纹饰我们可知工匠的所思所想，进而可以剥离出众多的历史信息。它具有很高的艺术价值，是历代艺术家取之不尽的源泉。

总之，珠宝在艺术价值上成就极高，特别是当代珠宝已由过去帝王将相的专享，成为普通人欣赏的艺术品，必将成为中国艺术史上最重要的元素。

黄翡鱼

虎睛石碟（三维复原色彩图）

925 银链莫莫红珊瑚白枝吊坠

3. 经济价值

　　珠宝的研究价值、艺术价值、经济价值互为支撑，相辅相成，呈现出的是正比关系。研究价值和艺术价值越高，经济价值就会越高；反之经济价值则逐渐降低。另外，珠宝还受到"物以稀为贵"、产地、品种等诸多要素的影响。其次就是品相，经济价值受到品相的影响。品相优者经济价值就高；反之则低。影响经济价值的因素还有很多，如磕伤、磨毛等，都会对珠宝的经济价值造成影响。具体情况我们在收藏时可以慢慢体会。显然，珠宝的经济价值需要综合判断。

珍珠标本

虢国墓出土玉戈·西周

海纹石单珠

二、保值与升值

　　珠宝在我国有着悠久的历史。在汉唐时期就使用珠宝，宋元以降，明清为盛，当代人们更为趋之若鹜。因为有着深厚的文化底蕴，加之其稀缺性的特征，珠宝的保值、升值功能已经成为必然。

　　从历史上看，珠宝是一种盛世的收藏品。在战争和动荡的年代，人们对于珠宝的追求夙愿便会降低，起码从价格上是这样。而盛世，人们对于珠宝的情结就会高涨，珠宝会受到人们的追捧，很多人们听起来不太熟悉的珠宝都会成为热点。如葡萄石、海蓝宝石、砗磲、石榴石、橄榄石等，在民国时期实际上都很少见，但今日盛世，价格也是日胜一日。近些年来，股市低迷、楼市不稳有所加剧，越来越多的人把目光投向了珠宝收藏市场。在这种背景之下，珠宝与资本结缘，成为资本追逐的对象，高品质珠宝的价格扶摇直上，升值数十上百倍，而且这一趋势依然在迅猛发展。

　　从品质上看，对珠宝品质的追求是永恒的。人们心目中的珠宝永远是最好的，质地温润、细腻、没有杂质，甚至没有瑕疵。这是对于珠宝永恒的追求，而不仅仅是检测证书上的矿物。如和田玉就是一个很好的例子，虽然韩国料也可以出和田玉的证书，但其质量却非常差，与新疆和田玉简直是两码事。这就是珠宝的品质。每一种珠宝几乎都有品质问题，只有高品质的珠宝才具有稀缺性，才具有保值与升值的潜力。

橄榄石碟（三维复原色彩图）

从产量上看，对于珠宝而言，珠宝的数量极为稀少，而高品质珠宝的产量更是有限。目前，全世界高品质珠宝的产量十分有限。如钻石的产量非常低，我国虽然也产钻石，但是可以应用于商业的几乎可忽略不计。因此，从产量上看，珠宝具备了"物以稀为贵"的商品属性，具有保值、升值的强大功能。

孔雀石执壶（三维复原色彩图）

从消耗上看，珠宝的消耗特别大，越是好的珠宝消耗量越大。如钻石的消耗，在中国就特别大，几乎成为每对新人的定情信物。其他的珠宝也是以各种各样的方式被消耗。一方面是不断的消耗，另外一方面珠宝不可再生，所以供不应求"物以稀为贵"的局面就会形成，且长期存在。而这些会在珠宝的价格上显示出来。

从保值与升值上看，珠宝已是"寸宝寸金"，价格与二十年前相比已经翻了上百倍。最普通品质的珠宝目前已是价格不菲，如果是高档珠宝的价格可以说是成千上万，价值连城。当然，并不是所有的珠宝都特别值钱。其实，任何一种珠宝都有低品质和高品质之分，每种高品质的珠宝在价格上都是相当贵重。如普通的玛瑙价格极低，每克仅几分钱；而品质最高的南红每克上千元，是上万倍的差价。可见，人们追求的是顶级珠宝。但是顶级珠宝总量是稀少的，原石在不断地消耗。总之，顶级珠宝的产量越来越低，而人们收藏的热情却是越来越高。但这对于资本而言并不是坏事，损耗，客观上使顶级珠宝的稀缺性进一步增加，珠宝保值、升值的功能必将进一步增强。

石榴石串珠

青金石摆件

925 银嵌海蓝宝石戒指

925 银链莫莫红珊瑚猴吊坠

参考文献

[1] 河南省文物考古研究所 . 河南商周青铜器纹饰与艺术 [M]. 郑州 : 河南美术出版社 ,1995.

[2] 安徽省文物考古研究所 , 含山县文物管理所 . 安徽含山县凌家滩遗址第三次发掘简报 [J]. 考古 ,1999(11).

[3] 姚江波 . 中国历代玉器赏玩 [M]. 长沙 : 湖南美术出版社 ,2006.

[4] 广西壮族自治区文物工作队 , 合浦县博物馆 . 广西合浦县九只岭东汉墓 [J]. 考古 ,2003(10).

[5] 徐州市博物馆 . 江苏徐州市花马庄唐墓 [J]. 考古 ,1997(3).

[6] 昭明 , 利群 . 中国古代玉器 [M]. 西安 : 西北大学出版社 ,1993.

[7] 南京市博物馆 . 江苏南京市明黔国公沐昌祚、沐睿墓 [J]. 考古 ,1999(10).

[8] 中国大百科全书 . 博物馆卷 [M]. 北京 : 中国大百科全书出版社 ,1993.

[9] 常熟市博物馆 . 常熟市虞山明温州知府陆润夫妇合葬墓发掘简报 [J]. 东南文化 ,2004(1).

[10] 何民华 . 上海市李惠利中学明代墓群发掘简报 [J]. 东南文化 ,1999(6).

[11] 贾兰坡 . 贾兰坡旧石器时代考古论文选 [M]. 北京 : 文物出版社 ,1984.

[12] 姚江波 . 中国玉器收藏鉴赏全集 [M]. 长春 : 吉林出版集团 ,2008.

[13] 青海省文物管理处 , 等 . 青海同德县宗日遗址发掘简报 [J]. 考古 ,1998(5).

[14] 董振信 . 宝玉石鉴定指南 [M]. 北京 : 地震出版社 ,1995.

[15] 南京市博物馆 , 等 . 江苏南京市邓府山明佟卜年妻陈氏墓 [J]. 考古 ,1999(10).

[16] 南京市博物馆 . 江苏南京市板仓村明墓的发掘 [J]. 考古 ,1999(10).

[17] 姚江波 . 古玉珍赏 [M]. 北京 : 印刷工业出版社 ,2011.